THE SHAPE OF THINGS

GW00771811

The Shape of Things A Philosophy of Design

Vilém Flusser

REAKTION BOOKS

Published by Reaktion Books Ltd
79 Farringdon Road, London EC1M 3JU, UK
www.reaktionbooks.co.uk

First published in English 1999
English-language translation © Reaktion Books 1999

Translated by Anthony Mathews

Designed by Ron Costley
Photoset by D R Bungay Associates
Printed and bound in Great Britain by
St Edmundsbury Press, Bury St Edmunds, Suffolk

British Library Cataloguing in Publication Data:
Flusser, Vilém, 1920–1991
The shape of things : a philosophy of design
1.Design – Philosophy
I.Title
745.4'01
ISBN 1 86189 055 9

Contents

Introduction

Design is a process that has been variously defined over the years, a process over which many different interest groups have claimed hegemony where the design of spacecraft, aircraft, ships and weapons is concerned, it has always been accepted as a matter of specialist technical expertise. Where grand buildings are under consideration, Art History rules, with Royal Commissions, government departments, local-authority officers and celebrated architects sharing a duty of agreement based on value judgements. In the realm of the consumer, the task of design is constrained by polls, surveys and focus groups, with advertising reinforcing the result and the power of the manufacturer supreme. Where clothes, cars, fashion and furniture are in question, individual genius may appear to be welcome, but distinctions without differences will abound.

For the media philosopher Vilém Flusser, none of the foregoing was of any importance. Flusser understood design in a different way, seeing it as a fit subject for etymological analysis. For this reason, the collection of his essays assembled here not only sheds new light on the importance of design, but also sheds light from an unusual angle. Flusser's insights flow not from professional design experience, but from empirical observation. Not from the conventional art-historical critique of form-giving, but from a self-taught grounding in linguistic philosophy that enabled him to deconstruct the design agenda and then reconstruct it in another way. For Flusser, as the reader of these essays will discover, design began not with science, not with the appreciation of fabricated objects, not with the vision of their creators, not even with the fabled first doodle on the back of an envelope. Instead, it began with the meaning of the words and the ensuing discovery of identity.

Just as evolution by natural selection proceeds in the natural world, design by semantic selection makes its discur-

sive, apparently wasteful way in Flusser's world towards the perfect reconciliation of needs with resources. Through infinite varieties of form and thought, from Galileo to the Gulf War, it follows in the footsteps of language, sifting and selecting a profusion of alternative objects and viewpoints in the world made by humans. Much as the environment sifts and selects organisms for survival in the natural world, Flusser found meanings and drew them to the surface. Words and the languages in which they are packaged became the means whereby blind, evolutionary-niche-filling design proliferates and cross-fertilises unpredictable patterns of survival.

Flusser's world view provides a primer for the number-crunching reality of what might be called 'real design': a definition that illuminates the vital but random and 'uncreative' roles of invention and technology-transfer even as it diminishes the false claims made for individual genius as well as the distortions encouraged by national chauvinism. For example, in his question-marked essay 'The Ethics of Industrial Design?', Flusser not only explains apparently arbitrary connections like the link between the cavity magnetron valve and the microwave oven, or that between the Polynesian wooden fishing canoe and the development of polymers and composites; or the relevance of bone china to the production of chocolate, of mathematics to computers, of computers to genealogy, and of genealogy to ecology – he also illuminates the crisis of moral responsibility that occurs because of these connections. He posits the state of ultimate irresponsibility that arises when the work of several anonymous designers combines to produce a 'post-industrial helicopter-pilot complex' of human-and-helmet that allows the pilot to aim and fire his guns simply by looking at his target and blinking.

Flusser's essays explain and illustrate this inextricable inter-connectedness of technology and responsibility by tracing genetic design chains back into the past. Into old worlds of hardship, self-sacrifice, resourcelessness, survival and ultimate

8

defeat. For he understood that real design is a language whose meaning can best be deciphered under extreme conditions – want of knowledge, of resources, of materials, of time – want of everything except language and the historically and geographically varied descriptors it provides. Products and systems created in such circumstances, he believed, truly held within themselves the most extreme state of efficiency for the task of species survival. They represented design on the edge of feasibility, where nothing could be done but somehow the possibility of something emerging through human understanding remained until the very end. That is where Flusser's vision of the ultimate role of design is to be found: in a crowded and polluted world where people will live in virtual reality most of the time and don special 'diving suits' to visit the real world.

If it is the surprising language and the complete absence of the usual list of famous designer names that gives Vilém Flusser's essays on design their freshness and continuing relevance, this is because they are simple without being simplistic. They have a directness that clears the ground. There is no overarching narrative, no fragmentation; every essay is complete. There is no naïve faith in science, no hero-worship, no corporate 'we', none of the underwriting of the myth of individual genius that so often passes for understanding where writers on design are concerned. As well as finding no parade of famous names, the reader will find no contenders put forward for uncritical admiration. Nor, indeed, will he or she be presented with pages of expensive photography (hinting as it invariably does that a deal has been done on the basis of a total suspension of critical faculties).

On the contrary. Flusser's liberated viewpoint permitted him a tremendous freedom of expression, a freedom, one might say, without equal in contemporary design literature. As a result, his writing became by turns pyrotechnic and witheringly critical, as well as pungent with meaning. All expressed in

short, stabbing essays replete with dazzling generalizations which turn out to be supported by an impregnable structure of argument drawn from reality itself.

Vilém Flusser the philosopher was born in Prague on 12 May 1920 into a family of Jewish intellectuals. His father, Gustav Flusser, was a Professor of Mathematics at Charles University; his mother was an artist. But despite his secure bourgeois background, his relations with his native country were destined to be short and tragic. The Republic of Czechoslovakia into which he was born had only recently been formed from two breakaway provinces of Austria-Hungary and had only nineteen years of life ahead of it. Flusser grew up in this fragile creation of the Treaty of Versailles and, against all probability, was destined to die in 1991 in its newly liberated Cold War successor, for although he left Prague at the age of nineteen and did not return until he was seventy-one, he died in a car crash on the outskirts of the city.

The Czechoslovakia of Flusser's childhood and youth was one of Europe's most cosmopolitan and avant-garde centres of art, industry and design. Occupying the industrial heartland of the old Austro-Hungarian Empire, it inherited – along with a population of only 14 million – an enormous excess of raw materials and an industrial capacity sufficient for a population of 60 million or more. From its inception, the new republic was an industrial producer and exporter, and its exports opened it up to world influences. Modern design flourished in the arts and in architecture, in the aircraft and motor industries and in the manufacture of military equipment. By the mid-1930s, Prague was boasting the most advanced collection of modern buildings in the world. Outside the capital, the model industrial city of Zlin was planned by the Swiss architect Le Corbusier as the first and only city to be three-dimensionally modular. In the same way, the Bata factory city of Brno boasted the first and only building to be equipped with mobile offices in lifts.

Whether Flusser's interest in design was triggered by this uniquely modern heritage is impossible to say. In any case, the window of opportunity for the small country was already closing. Czech independence was threatened as soon as Germany and Austria reunited in defiance of the Treaty of Versailles; within a year, Hitler had annexed the formerly Prussian Sudetenland and incorporated the two provinces of Bohemia and Moravia into the Reich. This last event, the second of no less than five radical restructurings the state of Czechoslovakia was to undergo in the twentieth century, placed the young Flusser in mortal danger.

In 1939, in his first year as a student of philosophy at his father's university, Flusser narrowly escaped the appalling fate of most of the Jews trapped inside the frontiers of Hitler's Germany. Thanks to the determination and family resources of a fellow student, Edith Barth, daughter of a wealthy industrialist, he was extricated from the country after the outbreak of World War II, managing to join Barth in England. From there, the pair made their way to Brazil, where the Barth family had industrial interests. Vilem and Edith were married in Rio de Janeiro in 1941 and proceeded to raise three children. Flusser was to remain in South America for 30 years. His good fortune can be measured by the fact that he was the sole member of his family to escape the Holocaust.

Flusser's career as a philosopher began in São Paulo, where his family resettled from Rio in the 1940s. There he worked as the manager of a transformer factory, learned Portuguese, studied philosophy and wrote copiously. His first publication on the philosophy of language appeared in 1957. Later he abandoned industry and taught humanities to engineering students at the university. In 1963, he published his first book, *Lingua e Realidade* (Language and Reality); in 1964, he became co-editor of the learned *Revista Brasileira de Filosofia* (Brazilian Review of Philosophy). In the following year, he published an influential article in this review entitled 'The

Crisis of Science', a paper that attracted critical attention. In it, Flusser maintained that the uncertainty of pure science had been masked throughout the modern period by a Romantic vulgarization of the enormous pragmatic success of applied science. The contemporary crisis to which his title refers was largely due to the uncertainty that was surfacing at long last. 'Science', he wrote in 1964, 'has become automated and has transformed scientists into its own tools.'

This idea of productive processes so optimized by specialized tools, equipment and protocols that their operators become their real products was to recur in Flusser's writing, as it does in this collection. The essay included here under the title 'The Factory', for example, expresses this idea, although it was published many years later in Germany. With a characteristic Flusserian flourish, it begins with the proposition that 'the science, politics, art and religion of [any society] can be traced back to its factory organization and way of manufacturing pots.' This is followed by an even more extreme restatement, that 'human history is the history of manufacturing and everything else is mere footnotes', or – as the same thought appears elsewhere in these essays – 'All revolutions are technical revolutions.' In 'The Factory', Flusser dismantles this assertion and then reassembles it. He does this by defining the successive phases of the history of manufacturing – 'hands, tools, machines, robots' – and then moves on to show that, as they have evolved from one stage to the next, factories have not become places where goods are produced so much as places where new kinds of human beings are produced as well: 'First hand-man, then tool-man, then machine-man, and finally robot-man'. Flusser goes on to discuss the human implications of the 'dematerialization' of the robot factory and to describe its resultant post-historical fusion of *homo sapiens sapiens* with *homo faber*. Finally, like the composer of an adept piece of chamber music, he closes on a reprise, completing the loop of his argument by proving that manufacturing is congruent

with learning, since both processes are based on 'acquiring, producing and passing on information'. Thus he proves that human history can be seen as 'a history of manufacturing and everything else is mere footnotes'.

Although he published books in Brazil during the 1960s – *Lingua e Realidade* and the first version of his best-known work, *Filosofia da Caixa Preta* (Towards a Philosophy of Photography) (later to appear in a successful German edition and ultimately to be translated into seventeen languages, inexplicably excluding English), Flusser's principal achievement during his creative years in São Paulo was the development of the concept of philosophical science fiction and the invention of its accompanying literary form, the short philosophical essay, a genre that he swiftly made his own.

By the time he had reached his middle years, Flusser had become a man of fixed and somewhat eccentric habits. According to Brazilian friends, he was – and determinedly remained – domestically incapable and could not (or would not) drive. He refused to buy books, although he accepted them as gifts, and in his own writings he seldom if ever acknowledged other authors. Inflexible in his daily routines, he wrote in the mornings and socialized in the afternoons. His writing method evolved in the era of the portable manual typewriter, and he never changed it thereafter, despite the explosion of information technology through which he was to live and about which he was to philosophize. Daily he placed a light-weight top sheet and single carbon copy in his portable with its pica typeface. He rejected electric and electronic typewriters because he objected to the noises they made, and he rejected the offer of a word processor out of hand – despite once being given one as a present by his son Miguel, today the owner of a software company in São Paulo. Flusser defended his preference for manual over automatic machines by claiming that the silence between keystrokes coupled with the physical act of returning the carriage left to right, left to

right, punctuated his thoughts at the correct intervals for composition.

The length of Flusser's essays and his drastic editing procedures were similarly ritualized. Because he invariably typed single-spaced copy with narrow margins and seldom used more than four sheets of paper at a sitting, he tended to produce dense documents with up to 400 words per page. These were inherently difficult to edit in the traditional manner. Although on surviving manuscripts there is some evidence of deletion and revision, in general Flusser dealt with the problem of editing by rereading his essays on completion and, if he did not like them, scrapping the originals and writing them again from the beginning, sometimes in a different language. Fluent in Czech, German, French, English and Portuguese, and with knowledge of many other languages, he used their various etymologies as tools for changing or elaborating meaning, as well as breaking through blocks in his flow of words.

Of the fortunes of his short philosophical essays, we know only that most remained unpublished until the 1970s, when for a few months he wrote regular columns in two separate Brazilian newspapers, the *Estado de São Paulo* and the *Folha de São Paulo*, in the latter of which his contributions were entitled 'Posto Zero' ('taking no position') – a prudent stance during the years of the military dictatorship in Brazil. These newspaper pieces were ephemeral and have never been translated from the Portuguese, although they have been collected and published in Brazil. They are said to be reminiscent of his aggressive debating style and to reflect his sense of humour. There can be no doubt that they influenced and added pace and flow to the articles dealing with the arts, media and communications that he soon began contributing to American, French and German art and cultural magazines. During the late 1970s and 1980s, many of his best essays were written for the American magazines *Artforum, Main Currents,*

Leonardo and *Art International*. For the French, he contributed to *Artitudes*, *Théâtre Public* and *Communication et langages*. Essays written in German appeared in *European Photography*, *Design Report*, *Arch +* and a large number of newspapers and photographic magazines.

Today approximately 70 philosophical essays written in English survive in the Vilém Flusser archive in Germany. Probably another hundred, written in Portuguese, survive in Brazil, together with another 70 or so written in German towards the end of his life, from which the essays printed here were taken. Within this total output, which spans the period from the mid-1960s until Flusser's death and which excludes all his full-length books, there is inevitably some considerable duplication as a result of the coexistence of successive versions of the same text, together with differing versions of one text rewritten in another language. There are undoubtedly sufficient unpublished essays to fill a series of books.

In 1972, Vilém and Edith Flusser returned to Europe, at first to Merano in Italy and then to Robion in the south of France, where Flusser met and began his long-standing collaboration with the artist Louis Bec and where he adopted the peripatetic life of a writer and lecturer. He gave lectures and seminars at the Art Academy of Aix-en-Provence, the Ecole Nationale Supérieure de la Photographie in Arles and the University of Provence. But this was just the beginning.

Flusser's first appearance at a German cultural event took place in 1981 at the Düsseldorf Photography Symposium. Two years later, by which time *Filosofia da Caixa Preta* had been published in Germany to great critical acclaim, Flusser had become a popular speaker at scientific and artistic conferences concerned with the new media in Europe and the United States. It was during this time, reflecting on the extraordinary story of Flusser's life, that someone asked him if he considered himself an international man. 'Inter', he replied, 'but not national.' Flusser's last engagement before his ill-fated visit to

Prague in November 1991 took the form of a series of seminars on communications at the Ruhr University of Bochum, of which a complete video record exists.

Perhaps the oddest and most revealing essay in this collection on design is entitled 'The Submarine'. It exemplifies the writing style of Flusser's later German period – during which time he occupied himself with wide-ranging and topical questions – but also recalls the philosophical science fiction of his Brazilian days. In it, he appears to be recounting the story of a monstrous attempt to destroy humanity, but in reality he is composing a parable for the coming transformation of materialistic civilization. He begins by describing a global state of frenzied activity in which everything has ceased to work and 'the eventual destruction of the world of things was only a question of time . . . years rather than decades.' Then he recounts the response of 17 prominent experts, professional men and women who misappropriate public funds to build a gigantic submarine in an abandoned shipyard in Norway, as a kind of inverted Noah's Ark. Together they constitute a kind of 'collective super-brain' which they base at the bottom of the Pacific Ocean, whence they threaten everyone in the world with destruction unless they pledge allegiance to a number of ruling principles. At first, the submariners have some success, but soon the altruistic principles they propound unite humanity against them. The giant submarine and its occupants are destroyed. This is Flusser's metaphor for the revolt of belief against modernity and the return of reality to a world of intolerable abstraction.

'I tried all my life to find myself in order to commit myself,' Vilém Flusser once wrote in an autobiographical essay. 'But I did not even begin to live. I spent my life being available, and I am still available.' In the form of a rich tapestry of writings, of which this collection is the first to be published in English, the voice silenced forever on the morning of 27 November 1991 is still available.

About the Word *Design*

In English, the word *design* is both a noun and a verb (which tells one a lot about the nature of the English language). As a noun, it means – among other things – 'intention', 'plan', 'intent', 'aim', 'scheme', 'plot', 'motif', 'basic structure', all these (and other meanings) being connected with 'cunning' and 'deception'. As a verb ('to design'), meanings include 'to concoct something', 'to simulate', 'to draft', 'to sketch', 'to fashion', 'to have designs on something'. The word is derived from the Latin *signum*, meaning 'sign', and shares the same ancient root. Thus, etymologically, *design* means 'de-sign'. This raises the question: How has the word *design* come to achieve its present-day significance throughout the world? This question is not a historical one, in the sense of sending one off to examine texts for evidence of when and where the word came to be established in its present-day meaning. It is a semantic question, in the sense of causing one to consider precisely why this word has such significance attached to it in contemporary discourse about culture.

The word occurs in contexts associated with cunning and deceit. A designer is a cunning plotter laying his traps. Falling into the same category are other very significant words: in particular, *mechanics* and *machine*. The Greek *mechos* means a device designed to deceive – i.e. a trap – and the Trojan Horse is one example of this. Ulysses is called *polymechanikos*, which schoolchildren translate as 'the crafty one'. The word *mechos* itself derives from the ancient *MAGH*, which we recognize in the German *Macht* and *mögen*, the English 'might' and 'may'. Consequently, a machine is a device designed to deceive; a lever, for example, cheats gravity, and 'mechanics' is the trick of fooling heavy bodies.

Another word used in the same context is 'technology'. The Greek *techne* means 'art' and is related to *tekton*, a 'carpenter'.

The basic idea here is that wood (*hyle* in Greek) is a shapeless material to which the artist, the technician, gives form, thereby causing the form to appear in the first place. Plato's basic objection to art and technology was that they betray and distort theoretically intelligible forms ('Ideas') when they transfer these into the material world. For him, artists and technicians were traitors to Ideas and tricksters because they cunningly seduced people into perceiving distorted ideas.

The Latin equivalent of the Greek *techne* is *ars*, which in fact suggests a metaphor similar to the English rogue's 'sleight of hand'. The diminutive of *ars* is *articulum* – i.e. little art – and indicates that something is turned around the hand (as in the French *tour de main*). Hence *ars* means something like 'agility' or the 'ability to turn something to one's advantage', and *artifex* – i.e. 'artist' – means a 'trickster' above all. That the original artist was a conjurer can be seen from words such as 'artifice', 'artificial' and even 'artillery'. In German, an artist is of course one who is 'able to do something', the German word for art, *Kunst*, being the noun from *können*, 'to be able' or 'can', but there again the word for 'artificial', *gekünstelt*, comes from the same root (as does the English 'cunning').

Such considerations in themselves constitute a sufficient explanation of why the word *design* occupies the position it does in contemporary discourse. The words *design, machine, technology, ars* and *art* are closely related to one another, one term being unthinkable without the others, and they all derive from the same existential view of the world. However, this internal connection has been denied for centuries (at least since the Renaissance). Modern bourgeois culture made a sharp division between the world of the arts and that of technology and machines; hence culture was split into two mutually exclusive branches: one scientific, quantifiable and 'hard', the other aesthetic, evaluative and 'soft'. This unfortunate split started to become irreversible towards the end of the nineteenth century. In the gap, the word *design* formed a bridge

between the two. It could do this since it is an expression of the internal connection between art and technology. Hence in contemporary life, *design* more or less indicates the site where art and technology (along with their respective evaluative and scientific ways of thinking) come together as equals, making a new form of culture possible.

Although this is a good explanation, it is not satisfactory on its own. After all, what links the terms mentioned above is that they all have connotations of (among other things) deception and trickery. The new form of culture which Design was to make possible would be a culture that was aware of the fact that it was deceptive. So the question is: Who and what are we deceiving when we become involved with culture (with art, with technology – in short, with Design)? To take one example: The lever is a simple machine. Its design copies the human arm; it is an artificial arm. Its technology is probably as old as the species *homo sapiens*, perhaps even older. And this machine, this design, this art, this technology is intended to cheat gravity, to fool the laws of nature and, by means of deception, to escape our natural circumstances through the strategic exploitation of a law of nature. By means of the lever – despite our body weight – we ought to be able to raise ourselves up to touch the stars if we have to, and – thanks to the lever – if we are given the leverage, we might be able to lever the world out of its orbit. This is the design that is the basis of all culture: to deceive nature by means of technology, to replace what is natural with what is artificial and build a machine out of which there comes a god who is ourselves. In short: The design behind all culture has to be deceptive (artful?) enough to turn mere mammals conditioned by nature into free artists.

This is a great explanation, is it not? The word *design* has come to occupy the position it has in contemporary discourse through our awareness that being a human being is a design against nature. Unfortunately, this explanation will not satisfy

us. If in fact *design* increasingly becomes the centre of attention, with the question of Design replacing that of the Idea, we will find ourselves on uncertain ground. To take one example: Plastic pens are getting cheaper and cheaper and tend to be given away for nothing. The material they are made of has practically no value, and work (according to Marx, the source of all value) is accomplished thanks to smart technology by fully automatic machines. The only thing that gives plastic pens any value is their design, which is the reason that they write. This design represents a coming together of great ideas, which – being derived from art and science – have cross-fertilized and creatively complemented one another. Yet this is a design we don't even notice, so such pens tend to be given away free – as advertising, for example. The great ideas behind them are treated with the same contempt as the material and work behind them.

How can we explain this devaluation of all values? By the fact that the word *design* makes us aware that all culture is trickery, that we are tricksters tricked, and that any involvement with culture is the same thing as self-deception. True, once the barrier between art and technology had been broken down, a new perspective opened up within which one could create more and more perfect *designs*, escape one's circumstances more and more, live more and more artistically (beautifully). But the price we pay for this is the loss of truth and authenticity. In fact, the lever is about to lever all that is true and authentic out of our orbit and replace it mechanically with perfectly designed artefacts. And so all these artefacts become as valuable as plastic pens, become disposable gadgets. This becomes clear when we die, if not before. Because despite all the technological and artistic arrangements we make (despite hospital architecture and death-bed design), we do die, just as other mammals die. The word *design* has managed to retain its key position in everyday discourse because we are starting (perhaps rightly) to lose faith in art and technology as

sources of value. Because we are starting to wise up to the design behind them.

This is a sobering explanation. But it is also an unavoidable one. A confession is called for here. This essay has had a specific design in mind: It set out to expose the cunning and deceptive aspects of the word *design*. This it did because they are normally concealed. If it had pursued another design, it might, for example, have insisted on the fact that 'design' is related to 'sign': a sign of the times, a sign of things to come, a sign of membership. In that case, it would have given a different, but equally plausible, explanation of the word's contemporary situation. That's the answer then: Everything depends on Design.

Form and Material

A lot of nonsense has been talked about the word *immaterial*. But when people start to speak of 'immaterial culture', such nonsense can no longer be tolerated. This essay aspires to clear away the distorted concept of the 'immaterial'.

The word *materia* is the result of the Romans' attempt to translate the Greek term *hyle* into Latin. *Hyle* originally meant 'wood', and the fact that the word *materia* must have meant something similar is still suggested by the Spanish word *madera*. When, however, the Greek philosophers took up the word *hyle*, they were thinking not of wood in general but of the particular wood stored in carpenters' workshops. In fact, what they were concerned with was finding a word that could express the opposite of the term *form* (Greek *morphe*). Thus *hyle* means something amorphous. The basic idea here is this: The world of phenomena that we perceive with our senses is an amorphous stew behind which are concealed eternal, unchanging forms which we can perceive by means of the supersensory perspective of theory. The amorphous stew of phenomena (the 'material world') is an illusion, and reality, which can be discovered by means of theory, consists of the forms concealed behind this illusion (the 'formal world'). Discovered, indeed, in such a way that one recognizes how the amorphous phenomena flow into forms, occupy them in order to flow out into the amorphous once more.

We get closer to this opposition *hyle/morphe* or 'matter'/ 'form' if we translate the word *matter* as 'stuff'. The word *stuff* is both a noun and a verb ('to stuff'). The material world is that which is stuffed into forms; it gives them a filling. This is much more plausible than the image of wood being cut into forms. For it demonstrates that the world of stuff only comes about when it is stuffed into something. The French word for filling is *farce*; this makes it possible to claim that, from a

theoretical perspective, everything material in the world, everything made up of stuff, is a farce. This theoretical perspective, in the course of the development of science, entered into a dialectical relationship with the sensory perspective ('observation – theory – experiment'), and this can be seen as a stumbling-block to theory. It could even lead to the sort of materialism for which matter (stuff) is reality. Nowadays, however, under pressure from information technology, we are returning to the original concept of 'matter' as a temporary filling of eternal forms.

For reasons that would go way beyond the scope of this essay, there grew up, independently of the philosophical concept of matter, the opposition 'matter–spirit'. The original conception here was that solid bodies could be turned into liquid and liquid bodies into gas, in so doing escaping the field of vision. Thus, for example, breath (Greek *pneuma*, Latin *spiritus*) can be seen as a turning of the solid human body into gas. The transformation from solid to gas (from body to spirit) can be observed in one's breath in cold weather.

In modern science, the concept of changing states of aggregation (solid > liquid > gas and back again) has given rise to a different world-view, according to which, roughly speaking, this change takes place between two horizons. On the one horizon (the point of absolute zero), everything whatsoever is solid (material), and on the other horizon (at the speed of light), everything whatsoever is more than gaseous (high energy). (One is reminded that 'gas' and 'chaos' are the same word.) The 'matter–energy' opposition that arises here makes one think of spiritualism: One can transform matter into energy (fission) and energy into matter (fusion) (this is expressed in Einstein's formula). According to the world-view of modern science, everything is energy – i.e. the possibility of chance, improbable agglomeration, of the formation of matter. In such a world-view, 'matter' equals temporary islands consisting of agglomerations (warps) in high-energy fields of

possibility which intersect with one another. Hence all the fashionable nonsense talked nowadays about 'immaterial culture'. What is meant by this is a culture in which information is entered into the electromagnetic field and transmitted there. What is nonsense is not just the misuse of the term *immaterial* (instead of *high-energy*) but also the uninformed use of the term *inform*.

To return to the original opposition 'matter–form' – i.e. 'content–container'. The basic idea is this: When I see something, a table for example, I see wood in the form of a table. It is true that the table is being hard as I am seeing it (I bump into it), but I know that this state is transitory (it will be burnt and decompose into amorphous ash). But the table-form is eternal, since I can imagine it anywhere and at any time (see it in my mind's theoretical eye). Hence the form of the table is real, and the content of the table (the wood) is only apparent. This illustrates what carpenters do: They take the form of a table (the 'idea' of a table) and impose it upon an amorphous piece of wood. The tragedy here is that in so doing they not only in-form the wood (impose the table form on it) but also deform the idea of the table (distort it in the wood). The tragedy is therefore that it is impossible to make an ideal table.

This all sounds very archaic, but it is in fact so up-to-date that it deserves to be called a 'burning issue'. Take a simple, and hopefully plausible, example: Heavy bodies appear to roll around without following any rules, but in *reality* they behave according to the formula of free fall. The movement perceived by the senses (that which is material about the bodies) is apparent, and the theoretically intelligible formula (that which is formal about the bodies) is real. And this formula, this form, is without time and space, unalterably eternal. The formula of free fall is a mathematical equation, and equations are without time and space. There is no point in trying to ask whether '$1 + 1 = 2$' is also true at 4:00 p.m. in Vladivostok. There is just as

little point, however, in saying of the formula that it is 'immaterial'. It is the *How* of the material, and the material is the *What* of the form. To put it another way: The information 'free fall' has a content (body) and a form (a mathematical formula). This is approximately how it would have been put in the Baroque period.

But the question remains: How did Galileo come up with this idea? Did he discover it theoretically behind phenomena (Platonic interpretation), did he invent it as a means of *orientation* amidst bodies, or did he spend a lot of time playing around with bodies and ideas until he worked out the idea of free fall? The answer to this question will decide whether the edifice of science and art stands or falls, this crystal palace composed of algorithms and theorems that we call Western culture. To clarify this problem, to illustrate the question in formal terms, what follows is a further example from the time of Galileo.

It is all a question of the relation between heaven and earth. If the heavens, with the moon, the sun, the planets and the fixed stars, revolve around the earth (as they appear to do), then the heavens revolve in very complicated epicyclical orbits, some of which must be in reverse. If the sun is at the centre, and the earth becomes a heavenly body, then the orbits run in relatively simple elliptical forms. The Baroque answer to this question was that in reality, the sun was at the centre and the ellipses were real forms; the epicyclical Ptolemaic forms were figures of speech, fictions, forms invented to maintain appearances (to save phenomena). Today our thinking is more formal than it was at that time, and our answer goes like this: Ellipses are more convenient forms than epicycles, and therefore they are to be preferred. But ellipses are less convenient than circles, and circles unfortunately cannot be applied here. It is therefore no longer a question of what is real but of what is convenient, and it turns out that one can't simply apply convenient forms to phenomena (in this case circles), only the

most convenient of those that fit them. In short: Forms are neither discoveries nor inventions, neither Platonic Ideas nor fictions, but containers cobbled together for phenomena ('models'). And theoretical science is neither 'true' nor 'fictitious' but 'formal' (model-designing).

If 'form' is the opposite of 'matter', then no design exists that could be called 'material': It is always in-forming. And if form is the 'How' of matter, and 'matter' the 'What' of form, then design is one of the methods of giving form to matter and making it appear as it does and not like something else. Design, like all cultural expressions, illustrates that matter does not appear (is not apparent) except in so far as one in-forms it, and that, once in-formed, it starts to appear (become a phenomenon). Thus matter in design, as everywhere in culture, is the way in which forms appear.

Nevertheless, to speak of design being between the material and the 'immaterial' is not completely beside the point. There are in fact two different ways of seeing and thinking: the material and the formal. The Baroque period was material: The sun is really at the centre, and stones really fall according to a formula. (It was material and, for precisely that reason, not materialistic.) Our period is more formal: The sun at the centre and the equation of free fall are practical forms. (This is formal, and precisely for that reason not unmaterialistic.) These two ways of seeing and thinking result in two different ways of designing. The material one results in representations (for example, animal paintings on cave walls). The formal one results in models (for example, designs for irrigation canals on Mesopotamian tablets). The first way of seeing emphasizes the apparent in a form; the second way emphasizes the form in the appearance. Thus the history of painting, for example, can be seen as a process in the course of which material seeing (with some set-backs of course) takes on a leading role. An illustration of this is the following:

An important step in the direction of formalization was the introduction of perspective. For the first time, it was a conscious question of filling preconceived forms with material, of making phenomena appear in particular forms. A further step was made by Cézanne, for example, who managed to impose two or three forms at the same time onto one material (for example, to 'show' an apple from several perspectives). This was carried to the extreme by Cubism: It was a matter of displaying preconceived geometrical (mutually intersecting) forms, in the case of which the material only served to make forms appear. One can therefore say of this sort of painting that, moving between content and container, between material and form, between the material and the formal aspect of phenomena, it approaches that which is referred to, incorrectly, as the 'immaterial'.

All this, however, is just a lead-up to the production of so-called 'artificial images'. These make the question of the relation between material and form a 'burning issue' for the first time today. What is at issue is the technical equipment allowing one to display algorithms (mathematical formulae) as colour (and possibly moving) images on screens. This is different from designing canals on Mesopotamian tablets, different from designing cubes and cones in Cubist paintings, even different from designing plausible aeroplanes by the use of calculations. Because in the first case, it is a matter of designing forms for materials in which they will be encapsulated in the future (the form of canals, of *Demoiselles d'Avignon*, of Mirage jets), and in the second case it is a matter of 'pure' Platonic forms. The fractal equations, for example, that are displayed on screens as Mandelbrot's little gingerbread men lack material (even if they can be filled with material such as mountain ranges, storm-clouds or snowflakes). Such artificial images can be referred to (mistakenly) as 'immaterial', not because they show up in the electromagnetic field but because they display material-free, empty forms.

The 'burning issue' is therefore the fact that in the past (since the time of Plato and even earlier), it was a matter of forming the material to hand to make it appear, but now what we have is a flood of forms pouring out of our theoretical perspective and our technical equipment, and this flood we fill with material so as to 'materialize' the forms. In the past, it was a matter of giving formal order to the apparent world of material, but now it is a question of making a world appear that is largely encoded in figures, a world of forms that are multiplying uncontrollably. In the past, it was a matter of formalizing a world taken for granted, but now it is a matter of realizing the forms designed to produce alternative worlds. That means an 'immaterial culture', though it should actually be called a 'materializing culture'.

What is at issue is the concept of in-formation. In other words, imposing forms on materials. This has been apparent since the Industrial Revolution. A steel tool in a press is a form, and it in-forms the flood of glass or plastic flowing past it into bottles or ashtrays. In the past, it was a question of distinguishing between true and false information. True information was when the forms were discoveries, and false information was when the forms were fictions. This distinction is becoming pointless since we have started to see forms neither as discoveries (*aletheiai*) nor as fictions, but as models. In the past, there was a point in distinguishing between science and art, and now this has become pointless. The criteria for criticizing information is now more like the following questions: To what extent are the forms being imposed here capable of being filled with material? To what extent are they capable of being realized? To what extent is the information practical or productive?

It is therefore not a question of whether images are the surfaces of materials or the contents of electromagnetic fields. But a question of the extent to which they arise from material, as opposed to formal, thinking and seeing. Whatever 'material'

may mean, it cannot mean the opposite of 'immaterial'. For the 'immaterial' or, to be more precise, the form is that which makes material appear in the first place. The appearance of the material is form. And this is of course a post-material claim.

War and the State of Things

Goethe, as is well known, recommends that Man be 'noble, generous and good', thus showing how far we have left the Enlightenment behind. Imagine reading out Goethe's statement at a mass demonstration of fundamentalists in Algiers, for instance (albeit in an Arabic translation). One can nevertheless attempt to bring the qualities enumerated in Goethe's statement up to date. 'Noble' might be replaced by 'elegant', and 'generous' perhaps by 'user-friendly'. The difficulty would be to reformulate the word *good* for the end of the Millennium. In addition, one would have to define Goethe's term *Man* a little less precisely. Because since the demise of humanism, we can no longer speak of Man in general anymore. My essay entitled 'The Ethics of Industrial Design?' (see pp. 66–9) sets out to transfer Goethe's good, but probably overly ambitious, recommendation to the debate about design in the following terms: 'Let Man be elegant, user-friendly and good.'

Let one simple example illustrate the problem. Take the case of designing a paper-knife. Let the designer be elegant: Let the knife be exceptional without being obtrusive (i.e. noble). Let the designer be user-friendly: Let the knife be easy to handle without any special knowledge (i.e. generous). Let the designer be good: Let the knife be so efficient that it can cut through paper (or anything resistant). As has already been indicated, the notion of the good is problematic. After all, a knife can be too good: It can not only cut paper but also its user's finger. Perhaps, then, Goethe's recommendation needs to be reformulated slightly: 'Let Man be noble, generous and good, but – having said that – does he need to be all that good?'

What if one were to take as an example instead of the paper-knife one of those rockets that were deployed in the Gulf War. No doubt the designers of these objects are

extremely noble men: The rockets are elegant and can be considered as characteristic works of contemporary art. Nor is there any doubt about the designers being extremely generous people: Even though the rockets are complex systems, they are so easy to get to know your way around that any semi-literate lout on the Upper Euphrates could use them. One could, however, argue that the rockets' designers are much too good as people because these objects not only kill well (as they are supposed to do) but also set off other rockets which then kill whoever uses them.

The noble, generous and all-too-good designers of the Iraqi rockets were probably Russian engineers. Perhaps they had read Goethe (although in Russia they were more likely to have been made to read Schiller at secondary school). From the perspective of these noble men, there was nothing to criticize about the quotation from Goethe. The fact that the users of the rockets were killed represented a challenge for the designers to become even better. In other words: to design rockets that killed the killers of the first killers to be killed. This is what is called progress: Thanks to this feedback in design, men become better and better. And thus more generous and noble as well. Of course, such optimism – based as it is on dialectical materialism – can be criticized from other perspectives.

This is not the time or place to argue against the progressive improvement of design as a result of war. In other words: to accuse what is known as the military-industrial complex of being the origin of everything elegant, amiable and good. The Gulf War made plain yet again what it would be like if there were no wars. If in their day our ancestors in East Africa 100,000 years ago had not designed arrow-heads that were at the same time elegant, user-friendly and good (and that could therefore kill with elegant convenience), then we would probably still be laying into each other or into animals with our teeth and nails. It may be that war is not the only source of good design (perhaps sex is also involved here; see fashions in

clothing, for example). But whether one prefers to say 'Make love and war' or 'Make love,' it is certainly not in the interest of good design to say 'Make love not war.'

There are, however, people who are against war. They are not willing to be killed by rockets (although, when asked, they cannot say what kind of death they would prefer). Such people are prepared, in the interest of peace, to accept bad design. They are downright pleased if rockets, paper-knives and arrow-heads get worse and worse and thus become less and less elegant, less and less convenient. They are good people in a totally different sense of 'goodness' from the one intended. These good people are good for nothing but for simply exist-ing. They are anti-designers.

Admittedly, when you see them completely at home using the pavement designed in spite of them, one gets the impres-sion that they nevertheless do design things: jewellery for instance. But they cannot keep this up for very long because one cannot 'make love' forever (which the jewellery is intended for) without lapsing into 'making war'. One cannot at the same time be 'good in oneself' and 'good for something'; one has to make a choice to be either a saint or a designer.

There may be a way out of this dilemma: either war and an elegant, user-friendly life in the midst of good objects, or everlasting peace and a squalid, inconvenient life in the midst of badly functioning objects. Putting it another way: either bad and convenient or inconvenient and saintly. Perhaps one could propose a compromise: to design objects intentionally less well than one might do. For example, arrow-heads that continually miss, paper-knives that take less and less time to get blunt, rockets that tend to explode in the air. Of course, one would also have to put up with chairs that threatened to collapse under the sitter and light bulbs that were continually blowing out. This compromise between malevolence and saintliness is widely recognized as being the goal of various peace conferences (which are, unfortunately, only rarely

attended by designers themselves). In this case, Goethe's recommendation might go something like this: 'Let Man be noble, generous and more or less good, and thus, as time goes by, less and less noble and generous as well.' But then one would still not have escaped the question of good, for the following reasons:

Between pure good ('moral' good), which is good for nothing, and applied good ('functional' good), there can be absolutely no compromise, because in the end everything which is good in the case of applied good is bad in the case of moral good. Whoever decides to become a designer has decided against pure good. They may disguise this as much as they wish (for example, by refusing to design rockets and limiting themselves to designing doves of peace). They remain, by their very involvement, trapped within the ambit of functional good. If they in fact begin to inquire into the pure good of their activity (for example, by asking themselves what their design for a dove of peace might be good for in the end), they are forced not just to design the dove of peace badly, but not to design it at all. There can be no such thing as a bad designer acting out of nothing but pure good, because even the intention of producing a bad design is functional and not pure. If therefore a designer claims that he only designs objects that correspond to his idea of pure good (eternal values and all that), he is mistaken.

Unfortunately, this is the way it is with goodness: Everything that is good for something is pure Evil. Those saints are quite right who seek refuge in isolation from the world, living off roots and hiding their nakedness with leaves. To put this in rather more theological language: Pure good is pointless, absurd, and, wherever there is a purpose for anything, you will find the Devil lying in wait. From the perspective of pure good, there is only a difference of degree between the elegant and user-friendly designs of a chair and of a rocket: In both cases, the Devil is lying in wait. Because they are both functional!

We have wandered a long way from the Enlightenment and have ended up, by means of a back door as it were, with something like the theological speculations of medieval obscurantism. Since the technicians had to apologize to the Nazis for their gas chambers not being good enough – i.e. not killing their 'clients' quickly enough – we have once more been made aware what is meant by the Devil. We realize once more exactly what is lying in wait behind the notion of *good design*. Unfortunately, this does not stop us wanting to have elegant and convenient objects. We insist, despite what we know about the Devil, that the designer should be noble, generous and good.

About Forms and Formulae

The Eternal God (may His name be praised) formed the world out of chaos, out of what, according to the Bible, was 'without form, and void'. The neurophysiologists (may they remain nameless) have sussed Him out, and now every self-respecting designer is capable of copying, and doing better than, Him.

This is how it seems: For a long time, the forms to which God the Creator had given substance were concealed behind the substance, waiting there to be discovered. For example, the Lord had invented the form of Heaven and imposed it upon chaos on the first day of creation. Thus were the Heavens created. People such as Pythagoras and Ptolemy discovered and noted God's forms behind phenomena. They are circles and epicycles; this is what is known as research: discovering God's design behind phenomena.

Since the Renaissance, we have stumbled upon an amazing and heretofore undigested fact: The Heavens can, it is true, be formulated and formalized in Ptolemaic circles and epicycles, but better still in Copernican circles and Keplerian ellipses.

How is that possible? Did God the Creator use circles, epicycles or ellipses on the first day of creation? Or was it the Masters of Astronomy, not God the Master, who set out these forms? Is it that the forms are not God's but Man's? Is it that they may not exist eternally in the World Beyond, but that they exist to be formed and modelled in This World? Is it that they are not Ideas and ideals but forms and models? What is difficult to digest about all this is not God's demotion and His replacement by designers as Creators of the world. No, what is really difficult to digest about all this is that the Heavens (along with all aspects of nature) cannot be formalized in whatever way we might wish, as ought to be the case if we really had assumed

God's throne. Why, for example, do the planets follow either circular or epicyclical or elliptical orbits rather than quadratic or triangular ones? Why can we choose to formulate the laws of nature in a variety of ways but not in any way we wish? Might there be something out there that is prepared to swallow some of our formulae but that spits out others, spits them out in our face? Is there perhaps a 'reality' out there that allows itself to be informed and formulated by us, but that nevertheless demands that we adapt ourselves to it?

This question is difficult to digest since one cannot be the designer and the creator of the world and at the same time have to submit to this world. Fortunately ('Thank God' not being appropriate here), we have recently discovered a solution to this aporia. A solution that forms a loop like a Möbius strip. And it starts to look like this: Our central nervous system receives digitally coded stimuli from its environment (which naturally includes our own body). These stimuli are processed by the system, using what are as yet incompletely understood electromagnetic and chemical methods, to become perceptions, feelings, desires and thoughts. We perceive the world, feel, desire and think along the lines the central nervous system has processed, and this process is pre-programmed by the central nervous system. It is written into the system within our genetic information. The world has had the forms it has for us laid down within genetic information since life began on earth. This explains why we cannot impose any forms we wish upon the world. The world only accepts those forms that correspond to the program of our life.

We have managed to pull a fast one, not just one but a whole series, on the program of our life. We have in fact invented methods and machines that do something similar to the nervous system, only in a different way. We can compute the stimuli (particles) coming at us from all quarters in a different way to the central nervous system. We can produce different, alternative perceptions, feelings, desires and

thoughts. Apart from the world computed by the central nervous system, we can also live in other worlds. We can experience a multiple here and now. And the expression 'here and now' can have multiple meanings. This statement may seem fantastic, terrifying even, but there are more familiar terms for this state: 'Cyberspace' and 'virtual reality' are common euphemisms for it. They go together with the following recipe:

Take a form, any form, in fact any algorithm that can be expressed numerically. Feed this form via a computer into a plotter. Stuff the form thus created as completely as possible with particles. And there you have it: worlds ready to serve. Every one of these worlds is just as real as the central nervous system (at least the one we have had so far), providing it manages to stuff the forms just as full as the central nervous system does.

This is a fine witches' brew: We cook up worlds in any form we wish, and we do this at least as well as the Creator did in the course of the much-celebrated six days. We are *the* master witches' brewers, *the* designers, and this makes it possible, now that we have outsmarted God, to sweep away all the cant about reality, along with Immanuel Kant: 'Real' means anything we, with our social status, efficiency and perfectionism, give form to by the use of the computer; 'unreal' means anything (e.g. day-dreams, illusions) we do when we use the computer carelessly. For example, the dream image of the woman we love is not truly real because we have done our dreamwork carelessly. If, however, we give the job to a professional designer who may have a holograph at his disposal, he will come up with women we really love, not careless dreams. This is the way things look like they are going.

We have sussed out the Eternal God (may His name be praised), pinched his recipes, and now we can cook even better than Him. Is this really such a new story? What about Prometheus and the fire he stole? Perhaps we think we are just

sitting at computers, while in fact we are chained to Mt Caucasus? And perhaps there are eagles already sharpening their beaks so as to peck out our livers.

The Designer's Way of Seeing

There is a line in the *Cherubinischer Wandersmann* by the
seventeenth-century German religious poet Angelus Silesius
which I quote from memory: 'The soul has two eyes: one look-
ing into time, the other one looking way ahead into eternity.'
(Anyone who wants to be precise can look the quotation up
and get it right.) The way of seeing through the first eye has
undergone a series of technical improvements since the inven-
tion of the telescope and the microscope. Nowadays, we can
command a longer, deeper and sharper insight into time than
Silesius could have envisaged. Recently, we have even gained
the ability to condense all of time into a single point in time
and see everything simultaneously on a television screen. As
for the second eye, the way of seeing that perceives eternity:
Only in the last few years have we begun to take the first steps
towards its technical perfection. That is what this essay is
about.

The possibility of looking through time into eternity and of
representing what can be perceived in the process has only
become relevant since the third millennium. It was in those
days that people stood on the hills of Mesopotamia looking
upriver and foresaw floods and droughts and marked lines
on clay tablets indicating canals that were to be dug in the
future. At the time, these people were thought of as prophets,
but we would call them designers instead. This difference in
the way the 'second eye of the soul' is judged is critical.
The people of Mesopotamia in those days, like most people
nowadays, held the belief that this way of seeing involved fore-
seeing the future. If someone digs irrigation canals, he does
this because he can foresee the future course of the river. Since
the time of the Greek philosophers, however (and in the
meantime among all more or less educated people), the opin-
ion has been that this second way of seeing sees eternity, not

the future. Not the future course of the Euphrates but the form of all watercourses. Not the trajectory of a rocket but the form of all trajectories in which bodies move in gravitational fields. Eternal forms. Only nowadays, educated people do not share exactly the same opinion as the Greek philosophers.

If we follow Plato, for example (who calls the way of seeing through the soul's second eye 'theory'), we perceive through fleeting phenomena the eternal, immutable Forms ('Ideas') that exist in heaven. According to this scenario, what was happening in those days in Mesopotamia was that some people were perceiving and noting theoretical forms behind the Euphrates. They were the first to employ geometrical theory. The forms they discovered – e.g. triangles – are 'true forms' (in Greek, 'truth' and 'discovery' are the same word – i.e. *aletheia*). Yet when they marked the triangles into the clay tablets, they were recording them. For example, the sum of the angles of a drawn triangle is not exactly 180 degrees, even though this is exactly the case with a theoretical triangle. Mistakes occur in geometry as theory is translated into practice. This is the reason why no man-made water system (or rocket flight) goes totally according to plan.

We see things quite differently nowadays. We no longer think (in a word) that we discover triangles, but that we invent them. People in those days played with forms like triangles so as to be able to work out the course of the Euphrates with some degree of accuracy, and they then applied one after another of the forms they were playing with to the river until the river fitted it. Galileo did not discover the formula of free fall, he invented it: He tried one formula after another until the problem of heavy bodies falling worked out. Thus the theory of geometry (and the theory of mechanics) is a design that we force upon phenomena in order to get hold of them. This sounds more reasonable than the Platonic belief in heavenly Ideas, but in reality it is exceptionally unsettling.

If the so-called laws of nature are our invention, why do the Euphrates and rockets keep to them and not to other forms and formulae that are just as good? Admittedly, whether the sun orbits the earth or the earth orbits the sun is simply a question of design. But is the way stones fall a question of design? To put it another way: If we no longer share Plato's opinion that the designer of phenomena is in heaven and has to be discovered in theory, but believe instead that we ourselves design phenomena, why then do they seem to be as they are instead of looking the way we wish them to be? This unsettling aspect cannot be sidestepped here.

On the other hand, there is no doubt that forms, whether discovered or invented, whether made by a heavenly or a human designer, are eternal – i.c. free of all time and space. The sum of the angles of a theoretical triangle is always and eternally 180 degrees, whether we discovered it in heaven or invented it at the drawing-board. And if we warp the drawing-board and design non-Euclidean triangles with the sum of their angles being different, then such triangles are also eternal. The designer's way of seeing – both the human and the heavenly designer's – doubtless corresponds to that of the soul's second eye. Here there arises the following intriguing question: What does eternity actually look like? Like a triangle (as in the case of the Euphrates) or like an equation (as in the case of falling stones) or like something else? Answer: It may look any way it likes; thanks to analytical geometry, it can always be reduced to equations.

This could be the beginning of a technology of the soul's second eye. All eternal forms, all immutable Ideas, can be formulated as equations, and these equations can be translated from the numerical code into computer codes and fed into computers. The computer for its part can display these algorithms as lines, areas and (a bit later on) volumes on the screen and in holograms, out of which it can create 'numerically generated' artificial images. What one then sees with the soul's

41

first eye is exactly what is perceived with the soul's second eye. What appears on the computer screen are eternal, immutable forms (e.g. triangles) produced by eternal, immutable formulae (e.g. '$1 + 1 = 2$'). Paradoxically, these immutable forms can change: One can distort, twist, shrink and enlarge triangles. And everything that results from this is likewise an eternal, immutable form. The soul's second eye continues to look into eternity, but this is now an eternity that it can manipulate.

This is the designer's way of seeing: He has a sort of pineal eye (partitioning just like a computer in fact) that enables him to perceive and control eternities. And he can give orders to a robot to translate into the here and now that which is perceived and manipulated in the eternal (for example, to dig canals or build rockets). In Mesopotamia, he was called a prophet. He is more deserving of the name of God. But thank God he is unaware of this and sees himself as a technician or artist. May God preserve him in this belief.

The Factory

The name that zoological taxonomy gives to our kind – *homo sapiens sapiens* – expresses the opinion that we are to be distinguished from the kinds of hominid that preceded us by a double dose of wisdom. In light of what we have got up to, this is rather questionable. On the other hand, the name *homo faber*, being less zoological than anthropological, is also less ideological. It means that we belong to those kinds of anthropoids who manufacture something. This is a functional term since it allows one to introduce the following criterion: Whenever we find any hominid anywhere in whose vicinity there is a working-floor, and whenever it is clear that a hominid has worked in this 'factory', then this hominid should be referred to as *homo faber* – i.e. a real human being. For example, there are remains of ape skeletons which make it clear that the stones in their vicinity were collected by them and were worked in a factory-like context. Despite any zoological doubts, such apes are *homines fabri* – i.e. should be referred to as real human beings. Thus 'factory' is the common human characteristic, what used to be referred to as human 'dignity'. By their factories ye shall know them.

This is what prehistorians do and historians ought to do but do not always keep to: studying factories so as to identify the human being. In order to discover how Neolithic human beings lived, thought, felt, behaved and suffered, one can do no better than study pottery working-floors in detail. Everything, particularly the science, politics, art and religion of the society of the time, can be traced back to factory organization and the manufacture of pots. The same goes for all other periods. If, for example, a shoemaker's workshop from fourteenth-century northern Italy is subjected to close examination, the roots of Humanism, the Reformation and the Renaissance can be understood more thoroughly than by studying the works of

art and political, philosophical and theological texts. Because most of these works of art and texts were produced by monks, whereas the big revolutions of the fourteenth and fifteenth centuries originated in workshops and in the tensions contained within them. So anybody who wants to know about our past should concentrate on excavating the ruins of factories. Anybody who wants to know about our present should concentrate on examining present-day factories critically. And anybody who addresses the issue of our future should raise the question of the factory of the future.

If, then, one sees human history as the history of manufacturing and everything else as mere footnotes, the following rough periods can be distinguished: hands, tools, machines, robots. Manufacturing means turning what is available in the environment to one's own advantage, turning it into something manufactured, turning it over to use and thus turning it to account. These turning movements are carried out initially by hands, then by tools, machines and, finally, robots. Because human hands, just like apes' hands, are organs for turning (since the act of turning is genetically inherited information), then tools, machines and robots can be regarded as simulations of hands which extend one's hands rather like prostheses and therefore enlarge the pool of inherited information by means of acquired, cultural information. Accordingly, factories are places where what is available in the environment is turned into manufactures, and at the same time less and less inherited information and more and more acquired, learned information is introduced. These are places in which human beings become less and less natural and more and more artificial, for the reason that the things turned into other things, the manufactures, strike back at the human being: A shoemaker not only makes leather shoes; he also makes a shoemaker out of himself. To make the same point a bit differently: Factories are places in which new kinds of human beings are always being produced: first the hand-man, then the tool-man, then

the machine-man, and finally the robot-man. To repeat: This is the story of humankind.

We find it difficult to reconstruct the first Industrial Revolution, the one from hand to tool, even though it is well documented by archaeological finds. One thing is certain about it: As soon as a tool – e.g. a hand-axe – is introduced, one can speak of a new form of human existence. A human being surrounded by tools, such as hand-axes, arrow-heads, needles, knives – in short, culture – is no longer at home in the environment in the way that primitive man using his hands is: He is alienated from the environment, and he is both protected and imprisoned by culture.

The second Industrial Revolution, the one from tool to machine, is barely two hundred years old, and we are only just beginning to come to grips with it. Machines are tools that are designed and produced in accordance with scientific theory, and therefore they are more efficient, quicker to use and more expensive. Thus the relationship between human being and tool is reversed, and human existence changes. In the case of the tool, the human being is the constant and the tool is the variable: The shoemaker is seated in the middle of the work-shop, and when he breaks a needle he replaces it with another. In the case of the machine, it is the constant and the human being is the variable: The machine is situated in the middle of the workshop, and when the human being becomes old or ill, the owner of the machine replaces him with another. To all appearances, the owner of the machine, the manufacturer, is the constant and the machine his variable, but on closer inspection the manufacturer is also a variable of the machine or of the plant as a whole. The second Industrial Revolution has cast the human being out of his culture just as the first one cast him out of nature, and in this respect the machine factory can be regarded as a sort of madhouse.

The third Industrial Revolution, the one from machine to robot, is now at issue. It is still very much under way, its end is

not in sight, and so we ask: What will the factory of the future look like (the one our grandchildren will be familiar with)? The simple question about the actual meaning of the word *robot* brings difficulties with it. One possible answer might be: Machines are tools that are built according to scientific theory when science is understood as meaning chiefly physics and chemistry, and robots can additionally bring neurophysiological and biological theory and hypotheses into play. To express this in terms of the simulation of hands and bodies: Tools are empirical, machines are mechanical, and robots are neurophysiological and biological. It is a question of 'turning' more and more deceptively accurate simulations of genetic, inherited information into things. Because so far, robots provide the most accomplished way of turning things over to use. You can be certain that the factory of the future will be much more adaptable than those of today, and it will be sure to redefine the relationship between human being and tool in a totally new way. We can count on it being possible to overcome the crazy alienation of the human being from nature and culture such as it was at the height of the machine revolution. The factory of the future will cease to be a madhouse and will become a place in which the creative potential of *homo faber* will come into its own.

This is above all a question of the relationship between human being and tool. It is therefore a question of topology or, if you like, architecture. As long as manufacturing takes place without tools – i.e. as long as *homo faber* acts directly upon nature, using his hands to turn things to his own advantage and turn things into something else – during all this time one cannot identify a locality for the factory; it has no 'topos'. So-called primitive man working 'eoliths' manufactures things everywhere and nowhere. As soon as tools are introduced, specialized factory areas can and must be cut out of the environment. Places, for example, where flint is hewn out of rock, and others where flint is turned into something else, so as to be

turned over to use and turned to good use. These factory areas are circular features in the middle of which stands the human being from whom circles of tools radiate outwards, themselves encompassed within the circles of nature beyond. This factory architecture has been the norm for practically the whole of human history. With the invention of machines, this architecture has to change in the following way:

Given that the machine has to be situated in the middle, due to the fact that it is more durable and more valuable in the manufacturing process than the human being is, human architecture has to be subordinated to that of machines. At first in Western Europe and on the East Coast of America, then everywhere, there come into being enormous concentrations of machines forming clusters in a network of interaction. The threads in the network, being ambivalent, can be organized centripetally or centrifugally. Along the centripetal threads, things relating to nature and human beings are sucked into machines so as to be turned over to use and turned to good use. Along the centrifugal threads, the things and human beings turned into something else flow out of the machines. The machines are linked within the network, forming machine complexes, and these in their turn are linked to form industrial plants, and in the network human settlements form those places from which human beings are sucked into factories, only to be sucked out periodically, spewed out again from there. The whole of nature is drawn into the circularity of this mechanical suction. This is the structure of factory architecture in the nineteenth and twentieth centuries.

This structure will be changed fundamentally by robots. Not just because robots can be turned to more uses and so are basically smaller and cheaper than machines, but because they are not constant in relation to human beings. It becomes more and more apparent that the relationship between human being and robot is reversible and that they can only function together: the human being in effect as a function of

the robot, and by the same token the robot as a function of the human being. The robot only does what the human being wants, but the human being can only want what the robot can do. A new method of manufacturing – i.e. of functioning – is coming into being: The human being is a functionary of robots that function as a function of him. This new human being, the functionary, is linked to robots by thousands of partly invisible threads: Wherever he goes, stands or lies, he carries the robots around with him (or is carried around by them), and whatever he does or suffers can be interpreted as a function of the robot.

At first glance, it looks as though we are almost back to the pre-tool phase of manufacturing. Just like primitive man acting directly on nature using his hands and therefore manufacturing all the time and everywhere, future functionaries equipped with tiny or even invisible robots will be engaged in manufacture all the time and everywhere. Thus not only will the giant industrial complexes of the machine age die out like the dinosaurs and at best be exhibited in historical museums; workshops too will become redundant. Thanks to robots, everyone will be linked to everyone else everywhere and all the time by reversible cable, and via these cables (as well as the robots) they will turn to use everything available to be turned into something and thus turned to account.

Such a telematic, post-industrial, post-historical view of the future of *homo faber* has a catch, however. It is in fact the case that the more complex tools become, the more abstract their functions become. Primitive man using his hands could try and get by with concrete inherited information as to the use of the things available to be turned to his advantage. To make use of tools, the manufacturer of hand-axes, pots and shoes had to acquire this information empirically. Machines called not just for empirical information but for the acquisition of theoretical information as well, and this explains the need for universal education: elementary schools for learning how to use

machines, secondary schools for learning how to maintain machines, and universities for learning how to build new machines. Robots call for a much more abstract learning process and the development of disciplines that have not been generally accessible up to now. Linking human beings up telematically to the network by means of robots and the consequent disappearance of the factory (to be more accurate: the becoming immaterial of the factory) presume that all human beings are competent enough for this. This competence should not be taken for granted.

This provides a hint as to what factories of the future will look like: like schools in fact. They will have to be places where human beings can learn how robots function so that these robots can then relieve human beings of the task of turning nature into culture. In fact, the human beings of the future in the factories of the future will learn to do this by, with and from robots. Thus in the case of the factory of the future, we will have to think more in terms of scientific laboratories, art academies and libraries and collections of recordings than in terms of present-day factories. And we shall have to look upon the robot-man of the future more as an academic than as an artisan, worker or engineer.

But this gives rise to a conceptual problem that forms the nub of these observations: The classical image of a factory is the opposite of a school: A 'school' is a place of contemplation, of leisure (*otium, schole*), and a 'factory' is a place that has given up contemplation (*negotium, ascholia*); a 'school' is something to look up to, and a 'factory' is something to look down on. Even the Romantic sons of the founders of industry shared this classical view. Now the basic error of the Platonists and the Romantics is becoming clear for all to see. As long as the school and the factory are in fact separated and look down on one another, industrial chaos is the rule. When, however, robots begin to oust machines, it becomes apparent that the factory is nothing but an applied school and the school

nothing but a factory for the acquisition of information. And at this point, the term *homo faber* comes into its own for the first time.

This allows one to formulate the question of the factory of the future in terms of topology and architecture. The factory will have to be the place in which human beings altogether will learn by means of robots: what, why and how to turn things to use. And the factory architects of the future will have to design schools. To put this in classical terms: academies, temples of wisdom. What these temples will look like, whether they will be down to earth in a material sense or up in the air in a semi-material sense or else in a largely immaterial sense, is beside the question. The only crucial thing is that the factory of the future will have to be the place where *homo faber* becomes *homo sapiens sapiens* because he has realized that manufacturing means the same thing as learning – i.e. acquiring, producing and passing on information.

This sounds at least as utopian as the telematic society linked to a network and using self-regulating robots. But in reality, it is nothing but a projection of tendencies that can already be observed. Such factory-schools and school-factories are coming into existence everywhere.

The Lever Strikes Back

Machines are simulated organs of the human body. The lever, for example, is an extended arm. It increases the ability of the arm to lift and ignores all the other functions the arm has. It is more 'stupid' than the arm, but it therefore reaches further and lifts heavier loads.

Stone blades – made like carnassial teeth – are amongst the oldest machines. They are older than *homo sapiens sapiens*, and they can still tear today: because they are not in fact organic but made of stone. Paleolithic man probably also had living machines: jackals, for example, which he made use of in hunting as extended legs and carnassial teeth. As carnassial teeth, jackals are less stupid than stone blades; therefore stone blades are more durable. This may be one reason why both 'non-organic' and organic machines were used right up to the Industrial Revolution: knives as well as jackals, levers as well as donkeys, shovels as well as slaves. So as to be able to make use of the durability of one as well as the intelligence of the other. But 'intelligent' machines (jackals, donkeys and slaves) are structurally more complicated than 'stupid' ones. That is the reason why, since the Industrial Revolution, we have started to dispense with them.

The industrial machine differs from a pre-industrial one in that it is based on a scientific theory. Of course, the pre-industrial lever has a gut feeling about the principle of the lever, but only with the industrial lever does it know what it is about. This is usually expressed in the following way: Pre-industrial machines are empirical; industrial ones are produced by technology. At the time of the Industrial Revolution, science had a series of theories concerning the 'non-organic' world at its disposal – in particular, theories of mechanics. But when it came to the organic world, it had few ideas about theories. What kind of gut feeling a donkey might have had about laws

was a mystery not only to the donkey but to the scientists as well. Thus, since the Industrial Revolution, the ox has given way to the locomotive and the horse to the aeroplane. The ox and the horse cannot be produced by technology. As far as slaves were concerned, it was a more complicated business. Technological machines became not only more and more efficient but bigger and more expensive as well. For this reason, the 'Man/machine' relationship was reversed, and Man did not use machines anymore but was used by them. He became a relatively intelligent slave of relatively stupid machines.

In our century, this has changed a bit. Theories have become more sophisticated, and thus machines have become more and more efficient and at the same time smaller and, above all, more 'intelligent'. Slaves have become more and more superfluous and have sought refuge from machines in the service sector or have become unemployed. These are the familiar results of the automation and 'robotization' character-istic of what is happening in post-industrial society. But this is not the change that really matters. What is rather more impor-tant is the fact that theories are beginning to be available for possible application to the organic world as well. We are begin-ning to find out which laws govern the donkey's gut feeling. So in the future, technology will be able to produce oxen, horses, slaves and super-slaves. This might be called the second or 'biological' Industrial Revolution.

At the same time, it will become apparent that the attempt to build 'intelligent, non-organic' machines is at best a makeshift, and at worst a mistake; a lever does not have to be a stupid arm if it is built into a central nervous system. The high level of intelligence of the ox can even be surpassed by loco-motives built fully in accordance with 'biological' principles. The durability of the 'non-organic' can be combined with the intelligence of the organic in the future construction of machines. Soon the place will be crawling with stone jackals.

But this is not necessarily an ideal situation: to be crawling with stone jackals, oxen, slaves and super-slaves at the same time as we are trying to eat and digest the industrial by-products poured out by them. This cannot be allowed. Not only, in fact, because these 'stone intelligences' are becoming increasingly more intelligent and therefore not stupid enough to serve us. This cannot be because machines already strike back at us even when they are stupid. How much more will they strike back when they have become smarter?

The old lever is striking back at us: We have been moving our arms as though they were levers since we have had levers. We simulate that which we have simulated. Since we have been pastoralists we have behaved like herds of sheep and have needed pastors. This striking back on the part of machines is now becoming clear for all to see: young people dancing like robots, politicians making decisions based on computerized scenarios, scientists thinking digitally, and artists using plotters. Consequently, the fact that the lever is striking back will have to be taken into account in the future construction of machines. It is not enough simply to take the economy and ecology into consideration in the construction of machines. We will have to think about the ways in which such machines may strike back at us. A difficult thing to do considering that most machines nowadays are made by 'intelligent machines' and that we ourselves only look on from the side-lines, as it were, intervening only occasionally.

This is a problem of *design*: What should machines be like if their striking back is not to cause us pain? Or, better still: if it is to do us some good? What should the stone jackals be like if they are not to tear us apart and if we ourselves are not to behave like jackals? Naturally, we can design them in such a way that they lick us instead of biting us. But do we really want to be licked? These are difficult *questions* because nobody really knows what they want to be like. However, these issues need to be addressed before one can start to design stone

jackals (or mollusc clones or bacterial chimeras for that matter). And these issues are more interesting than future stone jackals and supermen. Are designers ready to address them?

Shelters, Screens and Tents

We are admittedly surrounded by a lot of stupid objects, but when it comes to shelter, umbrellas must be among the most stupid. Umbrellas (what Germans call *Regenschirme* – i.e. rain screens) are relatively complicated contraptions which refuse to work just when they are needed (when it is windy, for instance); they give inadequate protection, are inconvenient to carry around and generally threaten to poke other people's eyes out if they are not equipped with umbrellas too. Quite apart from the fact that umbrellas get left behind and taken by mistake. There are admittedly fashions in shelter, but in fact there have been no technical advances since the ancient Egyptians. Indeed, when the Bible says 'The Eternal God is thy refuge,' it is being blasphemous comparing God with such things.

When you see the speed and convenience with which giant circus tents are put up and taken down, you might think that we have not done too badly as regards shelter: It is not people's fault if they do not know how to do it properly, and they will soon learn to do it when they go camping. But when you consider parachutes (what Germans call *Fallschirme* – i.e. fall screens), you return to your original opinion regarding the stupidity of shelters. There you are jumping out of an aeroplane and the wind automatically opens the 'chute. But as soon as you are down on the ground, you have the devil of a job folding the 'chute up again. This illustrates what is so outrageously stupid about shelters, and about tents in general (tents being perhaps the very essence of shelter): Since the ancient Egyptians, architects (and tent designers in general) have not tumbled to the fact that they are dealing with the wind and not with gravity. The fact that the danger with shelters such as tents is not their falling down but their being swept all over the place by the wind. This will change. People will learn to think more 'immaterially' as soon as walls have been torn down.

If we again try and give expression to the tent's essential nature: It is a sort of protective covering providing a refuge that can be put up in the wind, used against the wind and then folded up again in the wind. Faced by such a description of the essential nature of the tent, who would not be reminded of sails? And in fact, the sail is precisely the form of tent that brings the wind under control for once. The tent as a shelter tries to resist the wind, but the tent as a sail tries to exploit the wind's power. The sail is as smart as the shelter is stupid: A properly built sailing-ship can almost sail against the wind and is only ever helpless when there is no wind. And a glider can manipulate the wind not only horizontally but also vertically. Thus designers of the future will have to think of their designs by analogy not with umbrellas but with kites made to dance in the wind by children. Cracking the problem of the essential nature of the tent reveals parachutes and gliders to be just two of many variations on the theme of a tent. Because this solution recognizes in the tent a screen that is blown by the wind. A screen wall is to a solid wall as being blown by the wind is to forming a wind-break: This is not a bad place to start an analysis of the cultural change bearing down upon us. Before going into the problem of walls, however, one must think about the wind, and this leads one into familiar territory. For example, the fact that one can, it is true, hear the wind (it often roars deafeningly), that one can feel it (it can knock one over), but that one cannot see the thing itself, only the often horrendous consequences of its passing. As soon as one goes from solid walls to screen walls, everything seems to become more immaterial.

A screen wall – whether it is anchored into the ground as in the case of a circus tent, opened up at the end of a stick as in the case of an umbrella, floats in the air as in the case of a parachute or kite, flaps on a mast as in the case of a sailing-ship or flag – is a wind wall. A solid wall, on the other hand, in whatever form it takes and no matter how many windows and

doors it possesses, is a rock wall. Thus a house, like the cave from which it derives, is a dark secret (like that 'secret place of the heart', a home), and a tent, like a nest in a tree, of which it is a descendant, is a place where people assemble and disperse, a calming of the wind. In a house, things are possessed; it is property, and this property is defined by walls. In a tent, things are experienced; it assembles experience, and this experience is subdivided and diversified by means of the tent wall. The fact that the tent wall is woven – i.e. a network – and that experiences are processed on this network is contained within the word *screen*. It is a piece of cloth that is open to experiences (open to the wind, open to the spirit) and that stores this experience. Since ancient times, the screen wall has stored images in the form of carpets; since the invention of oil painting in the form of exhibited pictures; since the invention of film in the form of projected pictures, since the invention of television, it has acted as a screen for electromagnetically networked images; and since the invention of computer plotters, the tent wall, now in an immaterial form, has made possible the subdivision and diversification of images thanks to the processing of its network. The screen wall blowing in the wind assembles experience, processes it and disseminates it, and it is to be thanked for the fact that the tent is a creative nest.

Design: Obstacle for/to the Removal of Obstacles

An 'object' is what gets in the way, a problem thrown in your path like a projectile (coming as it does from the Latin *ob-iectum*, Greek *problema*). The world is objective, substantial, problematic as long as it obstructs. An 'object of use' is an object which one uses and needs to get other objects out of the way. This definition contains within it a contradiction: an obstacle for/to the removal of obstacles? This contradiction is what is called the 'internal dialectic of culture' (if by 'culture' we mean the totality of all objects of use). This dialectic can be summed up as follows: I come across obstacles in my path (come across the objective, substantial, problematic world); I overturn some of these obstacles (transform them into objects of use, into culture) in order to continue, and the objects thus overturned prove to be obstacles in themselves. The more I continue, the more I am obstructed by objects of use (more in the form of cars and administrative machinery than in the form of hailstones and man-eating tigers). And I am in fact doubly obstructed: first, because I use them in order to continue, and second, because they get in my way. To put it another way: The more I continue, the more objective, substantial and problematic culture becomes.

This by way of an introduction – to the state of things as it were. In the case of objects of use, it is therefore possible to ask how and why these projectiles have been thrown into one's path. (In the case of other objects, such a question is pointless.) And the answer to the question is: They were projected as designs on the part of people who went before. They are projected designs that I need in order to continue and that obstruct me from continuing. In an attempt to break out of this vicious circle, I project designs myself: I myself throw objects of use into the path of other people. What form must I give these projected designs so that those coming after me can

use them to help them to continue and at the same time avoid being obstructed as much as possible? This is both a political and an aesthetic question and forms the central concern when it comes to *creating* things.

The question can also be formulated along different lines. In the case of objects of use, I come across designs projected by other people. (In the case of other objects, I come across something different, perhaps something quite Other.) Objects of use are therefore mediations (media) between myself and other people, not just objects. They are not just objective but inter-subjective as well, not just problematic but dialogic as well. The question about creating things can also be formulated in this way: Can I give form to my projected designs in such a way that the communicative, the inter-subjective, the dialogic are more strongly emphasized than the objective, the substantial and the problematic?

When it comes to creating things, one is faced with the question of responsibility (and thus with freedom). Faced with freedom, naturally. Whoever projects designs for objects of use (whoever produces culture) throws obstacles in other people's way, and nothing can be done about this (not even for example one's intention to promote emancipation). But the fact must be borne in mind that when it comes to creating things, one is faced with the question of responsibility, and this is what makes it possible to talk of freedom in relation to culture in the first place. Responsibility is the decision to answer for things to other people. It is openness to other people. If I decide to answer for something in creating my design, then in the object of use designed by me I emphasize the inter-subjective and not the objective. And the more I direct attention towards the object in the creation of my design (the more irresponsibly I design it), the more the object will obstruct those coming after me, and the area for manoeuvre in the culture will shrink. A glance at the current situation of culture is evidence of this: It is characterized by objects of use whose

designs were created irresponsibly, with attention directed towards the object. This is almost inevitable in the current situation (and has been since the Renaissance at least). At least since that time, those doing the designing have been people who have projected their designs onto objects so as to produce more and more useful objects of use. The objects resist these designs. This opposition seizes the attention of those creating the designs, making it possible for them to penetrate more and more deeply into the objective, substantial, problematic world, to become more and more familiar with it and to master it. This makes scientific and technical progress possible. This progress has such a hold that those creating designs meanwhile forget that other progress, progress in the approach to other people. Scientific and technical progress has such a hold that any act of creating designs responsibly is thought to be a backward step. The current situation of culture is as it is precisely because creating designs responsibly is thought to be backward-looking.

The prophets called this hold over us on the part of the objective world 'pagan', and objects of use that have a hold over people as objects they called 'idols'. From their perspective, the current situation of culture is characterized by idolatry. There are, however, indications that this attitude towards creating designs is starting to change. Such that designs are becoming less and less 'pagan' and more and more 'prophetic'. In fact, one is starting to free the term *object* from the term *material* and to design immaterial objects of use such as computer programs and communications networks. This is not to say that an 'immaterial culture' beginning to grow in this way would be less obstructive: It probably restricts freedom even more than the material one. But in creating such immaterial designs, the point of view of those creating the designs is, as it were, spontaneously directed towards other people. It is instructed by the immaterial itself about how to create designs responsibly. Immaterial objects of use are idols

(and thus worshipped), but they are transparent idols and make it possible for other people to see what is going on behind the scenes. Their mediated, inter-subjective, dialogic side is visible.

This is of course not enough of a reason to hope for a more responsible culture in the future. But there is an additional point to mention that may justify such optimism. Objects of use are after all obstructions that I need in order to progress, and the more I need them, the more I use them up. Used objects of use are those for which the design projecting them into one's path has been obliterated. They have lost the form projected upon them by design; they are de-formed and thrown away. This can be traced back to the second law of thermodynamics, which states that all material tends to lose its form (its in-formation). This principle does not hold any less well (if less impressively) in the case of immaterial objects of use: They too are on the road to entropy. We are beginning to become conscious of the temporal nature of all forms (and thus of all creation). Since entropy is beginning to obstruct us at least as much as objects of use are. The question of responsibility and freedom (this being the essential question of creation) arises not only in the process of designing but also in the process of throwing away objects of use. It may be that consciousness of the temporality of all creation (even that of immaterial designs) will contribute to a future situation in which things will be designed a bit more responsibly, resulting in a culture with less and less room for objects of use to act as obstacles and more and more room for them to serve as vehicles for interpersonal contact. A culture with a bit more freedom.

Why Do Typewriters Go 'Click'?

The explanation is simple: Clicking is more easily mechanized than sliding. Machines are stutterers even if they appear to slide. This becomes clear when cars and film projectors start to go wrong. But this explanation is inadequate. Because what lies behind the question is: Why do machines stutter? The answer is: Because everything there is in the world (and the whole world itself) stutters. This only becomes clear when one takes a closer look. Democritus already suspected it, but not until Planck was anyone able to prove it: Everything quantizes. Thus numbers, but not letters, correspond to the world. It is open to calculation but not to description. Therefore, numbers have to break out of the alphanumeric code and make themselves independent. Letters entice one into endless discussion *about* the world and have to be put to one side as not equal to the task. This is precisely what is happening. Numbers abandon the alphanumeric code in favour of new codes (the digital code, for example) and they feed computers. Letters (if they want to survive) have to simulate numbers. This is why typewriters go 'click'.

A few things need to be said here. For example, the fact that everything in the world stutters has only become apparent since people have started to count everything. In order to count it, everything has been split up into little bits ('calculi'), and then a number has been attached to every little bit. Perhaps, then, the fact that the world is a scattering of particles is a consequence of our counting? Not so much a discovery then, more an invention? Do we discover in the world what we have fed into it ourselves? Perhaps the world is only open to calculation because we cobbled it together in our calculations. It is not numbers that correspond to the world: We have set the world up in such a way that it corresponds to our number code. These are rather unsettling thoughts.

They are unsettling for the simple reason that they lead to the following conclusion: The world is now a scattering of particles because that is how we cobbled it together in doing our calculations. Before that, however (at least since the Greek philosophers), the world was described alphabetically. Therefore, at that time it had to adhere to the discipline imposed by the rules of discourse – i.e. the rules of logic rather than the rules of mathematics. In fact, Hegel was still of the opinion, apparently mad to us now, that everything in the world was logical. We are now of the opposite opinion: Everything in the world can be traced back to absurd chance events that can be worked out by the calculus of probability. Hegel was thinking in words (in 'dialectic' discourse), whereas we think in calculations (we process punctuated data).

The whole thing gets still more unsettling when one considers that Russell and Whitehead proved in *Principia Mathematica* that the rules of logic cannot entirely be traced back to the rules of mathematics. As is well known, these two men tried to manipulate logical thinking by using mathematics (the 'calculus of propositions') and came up against this irreducibility. Thus it is not possible to build a really proper bridge between the world of description (Hegel's world, for example) and the world of calculation (Planck's world, for example). Since we have applied the methodology of calculation to the world (i.e. at least since Descartes' analytical geometry), the structure of the world has changed beyond all recognition. News of this has got around slowly.

This may tempt us to conclude that it is up to us how the world is structured. If we wish to write a description of it, then it has all the appearance of logical discourse, and if we prefer to calculate, then it has the appearance of a scattering of particles. This would be jumping to conclusions, though. Only since we have calculated have we had machines (typewriters, for example), and we could not live without machines, even if we wanted to. We are therefore forced to calculate rather than

to write, and if we insist on writing, then we have to go 'click'. To all appearances, it seems as if the world had in fact to be cobbled together for the purposes of calculation but that the world itself demanded that it be cobbled together.

At this point in the brain teaser, it is a good idea to hold our horses a bit. Otherwise, one runs the risk of falling into an abyss (into the realm of religion). To avoid falling like this into a Pythagorean worship of numbers, it is necessary to examine the movements one makes while calculating, as opposed to those one makes while writing. In the days when one still wrote by hand, one made a line going from left to right (that is, if one lived in the West) that wound its way from one side of the paper to the other with occasional breaks. This was a linear movement. When one calculates, one picks little bits out of a large heap and assembles them in little heaps. This is a punctuated movement. First, one calculates (picks out) and then one computes (assembles). One analyzes in order to synthesize. This is the radical difference between writing and calculation: Calculation is directed towards synthesis, but writing is not.

People who subscribe to the cause of writing try to deny this. In calculation, all they see is the doing of sums, and this they call cold and unemotional. This is a downright mischievous misunderstanding. What calculation is all about is computing cold sums into new things that have never existed before. This white heat of creativity is closed to people who do not go in for calculation as long as they see calculation merely as a question of numbers. They are unable to experience the beauty and philosophical depth of some outstanding equations (Einstein's, for example). But now that one can re-code numbers in the form of colours, shapes and sounds with the aid of computers, the beauty and depth of calculation are there for all to feel. One can see its creative force on computer screens, hear it in the form of synthesized music, and in future one will probably be able to experience it 'hands on' through the use of holograms. The exciting thing about calculation is

not that it cobbles the world together (writing can do this as well), but that it is capable of projecting other worlds from within itself for all to feel.

There is not much point in pouring scorn on these synthetically projected worlds for being simulations of the actual world, for being fictions. These worlds are concentrations of dots, computations of sums. But the same goes for the 'actual' world we are thrown into. It too is computed by our nervous system calculating on the basis of punctuated stimuli, and this is then perceived as actual. Thus either the projected worlds are just as actual as the 'actual' world (if they assemble the dots in the same concentration as the 'actual' one), or the 'actually' perceived world is just as much a fiction as the ones projected. What the cultural revolution now under way is all about is that we have gained the ability to set alternative worlds alongside the one taken by us as given. That we are going from being the subjects of a single world to becoming the projections of many worlds. That we have started to learn how to calculate.

Omar Khayyam says: 'Ah love! Could you and I with fate conspire/To grasp this sorry scheme of things entire,/Would not we shatter it to bits – and then/Re-mould it nearer to the heart's desire?' People are starting to see that we are in the process of shattering the sorry scheme of things entirely to bits. Not, however, so that we can re-code it just as our heart desires. People should at last learn how to do arithmetic.

The Ethics of Industrial Design?

Not so long ago, this would have been an unnecessary question. The morality of things? The designer used to have the production of useful objects at the forefront of his mind. Knives, for example, had to be designed in such a way that they were able to cut through something well – including enemy throats. Over and above this, a design that was to be of use had to be accurate – in the sense that it was in accord with scientific facts. It had to look good – in the sense that it was able to provide the person who used it with an experience. The designer's ideal was pragmatic – i.e. functional. Moral, indeed political, considerations hardly came into it. Moral norms were decided by the public – either in the form of a superhuman authority, or by means of consensus, or both. And designers, along with those who used products, were subject to the same norms under threat of punishment – in this life or the next.

The question of the morality of things, of the moral and political responsibility of the designer, has, however, taken on a new significance (indeed an urgency) in the contemporary situation. There are at least three reasons for this:

First, there is no such thing as a public laying down norms any more. Even though there are still authorities (religious, political and moral) just as there were before, their rules can no longer claim people's trust; their competence in respect to industrial production is in doubt. Consequently, authorities have less and less credibility, not least because the communications revolution has destroyed the public sphere we had known hitherto. Their competence is questioned since industrial production has become extremely complicated and norms of any kind tend to be deceptively simple. Having thus become incompetent, every authoritarian generalization of norms tends to inhibit industrial progress or cause disorganization more than it provides a direction for people to follow.

The only authority that seems to be more or less intact is science. Of course, it always claims to be engaged in value-free research, and as a result it does provide technical norms but not moral norms.

Second, industrial production, including design, has developed into a complex network that makes use of information from various sources. The mass of information available to a producer goes way beyond the capacity of individual memory. Even if one uses artificial storage mechanisms, one is stuck with the problem of deciding which information is to be selected for further processing. Consequently, it has become necessary to act in teams combining human and artificial components; results cannot therefore be attributed to any single author. The design process is organized on an extremely co-operative basis. For this reason, no one person can be held responsible for a product anymore. Even if there were authorities creating norms, nobody would feel personally bound to them. The lack of moral responsibility that follows logically from the production process must inevitably also come up with morally objectionable products in the event of a failure to agree on what sort of ethical code is to be followed for design.

Third, in the past it was tacitly agreed that the moral responsibility for a product lay with the person who used it. If someone stabbed someone else with a knife, he carried sole responsibility, not the knife's designer. Here the production of knives was a sort of pre-ethical, value-free activity. This is no longer the case, however. Many industrial processes are carried out by automated machines, and it would be absurd to hold robots responsible for the use to which products are put.

Whom should one hold responsible for a robot killing somebody? The person who constructed the robot, the one who made the knife or the one who set up the computer program? Would it not equally be possible to attribute moral responsibility to an error in construction, programming or

production? And what about attributing moral responsibility to the branch of industry that produced the robot? Or perhaps the whole industrial complex, extending to the whole system to which this complex belongs?

In other words: A situation in which designers do not address themselves to these questions can lead to a total lack of responsibility. This is not a new problem, of course. It became terrifyingly apparent in 1945 when it was a question of deciding who was to be held responsible for the crimes against humanity committed by the Nazis. At the time of the Nuremberg trials, a letter written by a German industrialist to a Nazi official was discovered. In it, the industrialist timidly begs to be forgiven for having constructed his gas ovens badly: Instead of killing thousands of people at one go, only hundreds were being killed. The Nuremberg trials and, a bit later, the Eichmann trial clearly demonstrated that a) there are no longer norms that are applicable to industrial production; b) there is no such thing as a single author of a crime; and c) responsibility has been so watered down that in effect we find ourselves in a situation of total irresponsibility towards acts resulting from industrial production.

Recently, the Gulf War provided an even clearer illustration of this kind of problem, though on a less absurdly inhuman level than in the case of the Nazis. The death toll was in the region of one Allied soldier to a thousand Iraqis. This statistic was achieved by means of state-of-the-art industrial design. Design that was impressive in its efficiency, scientific accuracy and, no doubt, aesthetic achievement. Is talk of ethical or moral (let alone political) responsibility of any relevance here? Think of the image of a pilot leaving his helicopter after an air attack and going immediately to talk to a television reporter. He has still got his helmet on. When he turns towards the reporter, the guns on board his helicopter are pointing in the same direction. His helmet is synchronized with the guns; the go-ahead for an attack can be given by the blink of an eye.

Now who is responsible for this post-industrial helicopter-pilot complex, and who is responsible for what happens as a result of such an interwoven network of relationships? Can one imagine an authority capable of judging what happens – would this authority be a judge, a priest, a national or international parliament, a committee of engineers or experts on the analysis of complex systems?

If we do not manage – by going beyond ideology – to find a way of approaching a solution to the ethical problems of design, then Nazism, the Gulf War and similar events will go down in history as merely the opening stages of a period of destruction and self-destruction. The fact that we are beginning to wonder about such questions gives reason for hope.

Design as Theology

In the nineteenth century, people were of the opinion that West is West, East is East, and never the twain shall meet. This view was based on profound insight, since for the West the most terrible thing is Death, and for the East the most terrible thing is Life. In the West, one has to die (these are the wages of sin), and in the East one has to be born over and over again (this is punishment for crimes committed). 'Salvation' for the West is the overcoming of Death; for the East it is the overcoming of rebirth. Christ promises eternal life, Buddha liberation from life. In other words: In the West, one does not want to die but one has to, and in the East, one does not want to live (because this is seen as suffering) but one has to be born again. An unbridgeable gap appears to yawn between these two worlds. But when one holds a piece of Japanese equipment (for example, a pocket radio) in one's hand, then one feels the yawning gap beginning to close.

Nothing is easier than to trivialize this (up to now) unique event. The pocket radio is a product of Western applied science, and its design is Japanese. There have always been things like this. For example, Chinese porcelain was produced following English designs. Oriental cultural elements were probably already known in the Roman Empire, and by the same token Hellenistic ones were probably known in China. Not to mention Mongol dragons on Gothic cathedrals and gods' helmets from the time of Alexander at Angkor Wat. Design does not develop according to function but follows traders in their ships or on Silk Roads. One does not have to call on Christ or Buddha to understand the Japanese pocket radio. One only needs to think of the opening up of Japanese harbours by the American fleet or Japanese industrial espionage in Europe and America between the world wars. Then again, as soon as one starts to trivialize the situation like this,

one feels the phenomenon one is trying to explain slipping through one's fingers. Is it that the Toyotas on German Autobahns are to be likened not to Fiats but to the Golden Horde?

The Japanese pocket radio does not force Western applied science into an Oriental form; rather it is a synthesis within which both overlap. This is, when one comes to think of it, an extraordinary claim. Western science comes about thanks to the detachment made possible by theory, as when one takes up a critical and sceptical attitude towards the world of phenomena. The form of things Oriental comes about thanks to very specific and concrete experience, causing the distinction between the human being and the world to blur. The yawning gulf that was mentioned before opens up between scientific theories and the concrete experience of an inseparable unity. Then again, has the pocket radio managed to synthesize both of them? Has it managed to combine botany and ikebana, ballistics and archery, chess and the Japanese game Go into a new unity? Because the above argument leads to a claim that, in the case of the pocket radio, Japanese design was not simply imposed on a radio but arose out of it.

Perhaps one can approach this problem (a decisive one for the future) by trying to set the Western concept of *design* against Oriental notions. As far as we are concerned, *design* is often seen as the imposition of a form onto a formless mass. The form (*eideia*) is conceivable on the theoretical level: For example, one conceives in theory that a triangle is a form the sum of whose angles is 180 degrees. Now one takes what one has conceived in theory, imposes it upon something formless, and one has 'designed' (formed), for instance, a pyramid. Of course, one has to take on board the fact that the sum of the angles in something produced in this way is no longer exactly 180 degrees. No design can be 'perfect', can be completely identical with its model as conceived in theory. This is our own design problem, certainly not one as far as the Far East is

concerned. We can observe how forms such as written characters or paper flowers or simply the form of the tea ceremony arise in the hands of Oriental people. In this case, it is not a matter of imposing an idea on something amorphous. It is rather a matter of allowing a unifying form to arise out of oneself and the surrounding world. *Design* then – in the Far Eastern sense – is a kind of immersion in the Not-Self (for example, in paper, the paint-brush or paint) which defines the form of the Self in the first place (for example, in the form of a written character).

Whereas in the West, therefore, design produces people who engage with the world, in the East it is the way in which people spring up out of the world so as to experience it. If one takes the word *aesthetic* in its original sense (i.e. 'open to experience'), then in the East *design* is purely aesthetic.

Now it is not, of course, as if in the case of the pocket radio the Japanese designer has arisen out of the world in some sort of *unio mystica* with plastic material and copper wire. No more than, in the case of a Western pocket radio, the designer engages with the world from a theoretical perspective so as to give it form. Rather, both designers, the Eastern and the Western, are mindful, in the act of creation, of the market for, and function of, the object they are creating. But one must not be fooled by this apparent similarity. The Japanese designer comes out of a cultural context in which life is characterized by the Buddha – the 'Enlightened One' – and this can be seen reflected in his design: the bonsai trees and sliding doors, the sandals and the pocket radio, the Walkman and, in future, electronic and genetic robots and artificial intelligence. The design of all of these expresses the peculiar aesthetic quality of a blending in with the environment, a disintegration of the self. An eye trained in phenomenology would not be able to avoid seeing this in a pocket radio, a Toyota and a camera any more than it would in Japanese (and, for that matter, other Oriental) food.

This is an extraordinary claim for the following reason: Science and the technology based upon it could only arise on Western soil. They presuppose the detachment made possible by theory, but also the Jewish conviction that one must change the world so as to change oneself. Science is basically a method of discovering the Judeo-Christian God 'behind phenomena', and technology a method of producing God's kingdom on earth. As soon as one translates science and technology into Oriental design, they both have to change their nature.

This fateful change is already underway, even if we do not always register the fact. What is produced by Japanese laboratories is no longer the same sort of science as that which led to the Industrial Revolution, as it expresses a totally different 'spirit'. The industrial products made in Japan that are flooding the world do not breathe the same atmosphere as that breathed by the Industrial Revolution since the Enlightenment. And this will become even more apparent when China starts to become productively engaged in scientific and technological development. It is as though the motivation that originally created science and technology has done a U-turn. One way of looking at this fundamental U-turn is as follows:

The science we know takes place in the form of logical discourse, and this discourse is alphanumerically (en)coded. In other words, science describes and calculates nature according to the rules of linear writing and thought. The motivation of science is to seize hold of nature so described and calculated, in order to empower knowledge. In the Far East, there is no code that could be structurally compared to the alphanumeric. There, science and technology are only conceivable in English and in our numbering system. But now the alphanumeric code is being replaced by digital computer codes. These new codes have more in common with Oriental codes (e.g. ideograms) than with linear ones. So now science and technology are just as conceivable in the Far East as in the West. There is now another motivation behind them.

Seen from the West, what is taking place can be interpreted as a disintegration of the basic structures of Western culture. Products flooding in from the East come designed in such a way that, in the form of every one of them, we get a concrete experience of the Oriental life-style. From the shape of the Japanese pocket radio, we gain a concrete ('aesthetic') familiarity with the Buddhist or Taoist or Shinto approach to life. We experience the extent to which our way of thinking, which has led among other things to science and technology (but also to other, more frightening things), is being absorbed into the Oriental one. Much more than the various sects taking the Orient as their model that have sprung up particularly in America, it is the design of Oriental industrial products that is pulling the ground of Judeo-Christianity from under our feet and immersing us in the East. Seen from an Eastern perspective, the same thing probably seems to be happening in reverse. The advent of Western science and technology is no doubt interpreted as a disintegration of the Oriental life-style, and this becomes plain as soon as one compares the design of pocket radios with that of a kimono or of samurai swords.

Seen from a 'more objective' perspective, it is perhaps a blurring of East and West that one is talking about nowadays. Perhaps this mutual subversion is expressed in the design of *post-industrial* ('post-modern'?) products. But the nineteenth century was right after all in considering that a blending of Buddha into Christ or vice versa was impossible. The God of one is the Devil of the other. Perhaps a reduction to the lowest common denominator is taking place, a mutual destruction of values.

In this matter, it is necessary to put sincerity above a feeling for justice that reduces everything to the same level. There are, after all, only two peaks in human civilization: the Oriental one and our own. All the others are either overlaps between these two (India, for example) or the first steps in the direction of forms that have never been developed before. If, as appears

to be the case, the translation of Western science and technology to the Far East leads to a blurring of the two cultures, it is in fact 'mass culture' that one is talking about, a culture that finds its aesthetic expression in trashy design. But the meeting of East and West just getting underway can be seen in a different light. What if a new feeling for existence were to be finding expression in the design of post-industrial products?

At the beginning of this essay, it was suggested that the fundamental difference between East and West was their attitude to life and death. From the Western attitude there arose Greek philosophy, Jewish prophesy and hence Christianity, science and technology. From the Eastern attitude there arose an aesthetic and pragmatic approach to life that we Westerners have never been able to understand completely. Now, these two mutually exclusive attitudes can, indeed must, blend into one another. They have already produced various new codes (computer codes) that bridge the gap. Out of their amalgamation are produced a science and technology that can no longer be classified, their products being designed in a spirit that no longer fits the old categories. Shouldn't this sort of design perhaps be subjected to a 'theological' analysis to find out whether its attitude to life and death is moving onto a new plane? Is it that such design expresses a 'transcended' Judeo-Christianity and a 'transcended' Buddhism for which we still lack words? This is a bold hypothesis. But whenever one takes a Japanese pocket radio in one's hand and looks closely into its design, the hypothesis does not look all that speculative after all; on the contrary, its time has come. To indicate as much has been the aim of this essay, though admittedly, what is being suggested must be taken as provisional. Its intention is to be an *essay* – i.e. an attempt at a hypothesis.

Wittgenstein's Architecture

The universe of texts can be seen as a landscape. In it one can make out mountains and valleys, rivers and lakes, castles, farmyards and inner-city slums. On the horizon of the scene visualized in this way, the Bible and Homer appear as gigantic ice-covered mountains. The vast, tranquil lake of Aristotle's texts, where fishermen idly throw their nets and philologists row their boats, occupies a part of the valley bottom. There, the tumbling waterfall of Nietzsche is captured by the broad river of modern pragmatism. Towering above everything, the Gothic cathedral of St Thomas Aquinas's *Summae* dominates the cathedral square of the city, in which the roofs and gables of Baroque speculations jostle one another. In the suburbs of this city, one catches sight of the Romantic, Realist and Modernist housing-blocks and factories of more recent literature; somewhat apart from all these stands a small, apparently insignificant house resembling scaffolding more than a finished building: Wittgenstein's building.

This little house is called the *Tractatus*. This name isn't the product of a one-track mind. For when one enters the house, one notices immediately that this is not a place that has lost track of things. Quite the opposite: It is a place of mirror-images. The house stands on six foundation pillars which support one another by means of cross-beams organized in a hierarchy. In the middle, however, there rises a seventh pillar whose function it is to cut through the building and free it from the ground. So the house with all its corners, angles and joints is protected, armoured and impregnable. And yet, and for that very reason, it is threatened with collapse and disappearance without trace – condemned in advance and from the outset.

The building is set out: It consists of propositions. Every proposition presupposes all the preceding ones and is itself the

presupposition of all the following propositions. Proposition by proposition, anyone who enters progresses through the prescribed rooms, and his step is supported by consistencies. Suddenly, with one proposition, one single proposition, the ground gives way beneath his feet. He falls head first into the abyss.

Wittgenstein's house is situated in a suburb of that city whose cathedral square is dominated by the towers of Thomas Aquinas's cathedral. The small, modest pillars of Wittgenstein's house support one another according to the same logico-philosophical method as the pillars of the cathedral support one another. But there appears to be a world of difference between the cathedral and the little house: The cathedral is a ship pointing in the direction of heaven, and the little house is a trap-door pointing in the direction of a bottomless abyss. But be careful: May Thomas Aquinas not have been right in saying after his revelation that everything he had written before was like straw? May not the heaven above the cathedral be the same black hole as the abyss beneath the little house? May not Wittgenstein's little house be the cathedral of today? And those mirrors whose images simultaneously mirror one another, may they not be our equivalent of stained-glass windows?

The landscape portrayed in this essay, it goes without saying, is a metaphor. Is it possible to identify it as Vienna? And is it possible for anyone entering Wittgenstein's little house in that unlikely place to make out a hint of the unsayable? What we cannot speak about we must pass over in silence.

Bare Walls

We talk of bare walls, just as we talk of the bare body, as things that should be covered up. It takes courage to show the body as it is: naked. We are inescapably part of the Christian tradition. And in this tradition, nakedness means nature. Nature exists to be altered by Man, that 'God-like spirit'. Nature is that which is taken for granted and has to be transformed into something man-made: into culture. In other words, nakedness belongs to entropy and has to be covered up by the activity of the human spirit working against entropy. Walls stand naked before us in defiance of the human will to form a design. Standing out against walls, Man identifies himself as a creature who opposes the formless chaos represented by the world.

Yes, but are walls really something to be taken for granted? Of course not. They are built by human beings, and we know this not only from the 'historical' point of view (we know who built them, how and why) but from the 'structural' point of view as well (we know they have an un-natural structure).

This gives rise to both a historical and an existential question. The historical problem goes like this: For a caveman, cave walls were taken for granted, and he opposed them by painting on them and expressing his will in opposition to nature (an expression of 'beauty'). Our walls are late and decadent forms of cave walls. The existential problem is as follows: Although our walls were made by human beings (by masons, architects and those who impose their ideology on masons and architects), they are nevertheless taken for granted as far as those living between them are concerned. It is a mistake to say that culture is made by human beings and is therefore the realm of human freedom. For everyone living in a culture, it is something taken for granted just as nature is. Therefore, walls are taken for granted. They are taken for granted even by those who build them.

Nevertheless, we must admit to a strange ontological ambivalence on the part of walls: Seen from the inside, they are taken for granted; seen from the outside, they are man-made. (This is a difference between the cavemen and us: A caveman could not see his walls from the outside; he had no 'philosophical distance'.) We can step out of our own four walls and see not just the outside world but our own four walls as well. We are creatures of reflection and speculation. We can therefore do something the caveman could not do: develop a philosophy of culture. And culture appears to us in the form of a steadily growing collection of things that we place up against the four walls of our dwelling to cover up their nakedness and hide the fact that they are taken for granted. Sometimes, these things representing culture cover up more than just the nakedness of the walls. They cover cracks in the walls and conceal the possible danger of the building collapsing and burying us under the rubble.

This image of culture becomes even more plausible if we imagine one of the four walls being knocked down and trans-formed into a window without any glass in it. The three remaining walls then become like a stage on which the tragi-comedy is enacted – quite a valid historical image of culture: Man as an actor on the stage. The valid historical thing about this image is its representative (symbolic) nature and the fact that it is a question of a historically finite process. Culture thus appears as 'fiction' (in the sense of *fingere*, 'to form', 'to design'). The three remaining walls conceal the pathos with which Man seeks to impose his will on nature, and they also conceal (by reason of universal inertia) the possibility of his own defeat – since even the three remaining walls will collapse in the 'end'.

Nevertheless, and despite the fact that we all know this, Man will still go on filling the space between the walls with things, as witnesses to his power of design. He will do this simply because the walls exist and must not be left bare. And

whenever there are moments in history when there is a will to reveal nakedness (moments of an inverted Puritanism that insists on the beauty of nakedness and the functional purpose of the walls), these moments are then the dialectical part of the process in which Man covers up his walls. This process does not aim to do away with the walls (that is impossible), but as Living-between-Walls is part of the human condition, he strives to make the best of them. Every cultural undertaking thus becomes a 'heroic commitment' in the true sense of the word, and art becomes a tragedy and agony in the sense it had for the Greek theatre.

In short, seen from an aesthetic point of view, walls are the borders of a stage on which the tragedy of the human striving for beauty is enacted.

With As Many Holes As a Swiss Cheese

Houses are made up of a roof, walls with windows and doors, and other parts that are not quite so important. The roof is the important thing: 'homeless' and 'without a roof over one's head' are synonyms. Roofs are devices to make us subservient: Under them one can cower and hide from one's lord (be he a God or Nature). The German word for roof, *Dach* (like the cognate English word *thatch*), comes from the same root as the Greek *techne*; accordingly, roof-tilers and thatchers are artists. They draw the line between the province of the Laws and the private space of the subservient slave. Under one's own roof, the Laws are only valid up to a point. The tree-tops served as a roof for early hominids' nests. We do not think that we ourselves are the ones who project the Laws. We do not need any roofs.

Walls are there for us to defend ourselves against the outside world, not against the world over our heads. The German word for house walls, *Mauern*, like the French *murs*, comes from *munire*: to protect oneself. They are munitions. They are made up of two walls: The outside wall turns to face dangerous aliens (lurking on the outside), would-be immigrants; the inside wall turns inwards to the inmates of the house like a jailer responsible for their security. In the case of walls without roofs (e.g. the Berlin Wall and the Great Wall of China), this function becomes clear: The outside is political, the inside wall secretive, and the wall has to protect the secret place of the heart from being visited by evil spirits. Anyone who can't stand secretiveness should go ahead and knock walls down.

But even secret-mongers and patriots have to knock holes in walls. Windows and doors. So as to be able to look outside and go out. Before the verb *to show* came to have the meaning 'to display', it was used in the sense of 'to see' – i.e. looking out from inside, for which the window provided the device. One looked out from inside without getting wet at the same time.

The Greeks called this sort of seeing *theoria*: perception without danger and without experiencing anything. Now it is actually becoming possible to push devices through the window into the outside world to experience things in such a way that one does not run any sort of danger whatsoever. The phenomenological question raised by this is: Are experiments carried out through the window (i.e. in theory) valid? Or does one have to go out the door to experience things?

Doors are holes in walls for going in and out. One goes out to experience the world, and there one loses oneself, and one returns home in order to find oneself again, and in so doing one loses the world that one set out to conquer. This back-and-forth through the door Hegel calls the 'unhappy consciousness'. In addition, it can happen that on returning home one finds the door locked. It is true that one has a bunch of keys in one's pocket (or one can decode the secret code), but the secret code may have been re-coded in the meantime. Home and homeland are favourite places for con-tricks. Then one is stuck outside in the rain, practically in the gutter. Doors are devices that do not provide happiness, nor are they to be trusted.

In addition, the following objection can also be made to windows and doors: One can look in through windows from the outside and climb in through them, and the public sphere can break into a private house through the door. One can of course protect windows from spies and burglars by installing shutters or protect the door from the police by building a drawbridge, but then one lives in fear, stuck within one's four walls. There is not much future in such architecture.

Roofs, walls, windows and doors do not fulfil their function anymore, and this explains why we are beginning to feel homeless. As we can't really go back to tents and caves (even if some people try to), for better or worse we have to design a new type of house.

In fact, we have already started to. Home-as-one's-castle with its roof, walls, windows and doors now only exists in fairy

tales. Material and immaterial cables have knocked as many holes in it as in a Swiss cheese: On the roof there is the aerial, telephone wire comes through the wall, the television takes the place of the window, and the door is replaced by the garage with the car. Home-as-one's-castle has become a ruin with the wind of communication blowing through the cracks in the walls. It is a shoddy patchwork job. What is needed is a new type of architecture, a new design.

Designers and architects must no longer think in terms of geography but in terms of topology. Enough of the house as an artificial cave; it is more a warping of the sphere of interpersonal relations. Such a change in the way we think is not easy. The change from thinking in terms of flat surfaces to thinking in terms of the surface of a globe was an achievement for its time. But thinking in terms of topology is made easier by the use of synthesized images of mathematical equations. Thus, for example, one no longer sees the earth as a geographical location in the solar system but as a warp in the gravitational field of the sun. This is what the new type of house must look like: a warp in the interpersonal sphere by which relationships are 'attracted'. Such an attractive house would have to assemble these relationships, process them in the form of information, store them and pass them on. A creative house as the nucleus of an interpersonal network.

Such a method of building a house using cable links is full of dangers. For example, the cables can be connected up, not to networks, but to the masses: something 'fascistic' rather than 'dialogic'. Like televisions, not like telephones. In such a worst-case scenario, houses would be the cornerstones of an unimaginable totalitarianism. Architects and designers must provide a network of reversible cables. This is a task for technology, and designers are up to it.

To be sure, such a method of building houses would be a technological revolution that would go far beyond the competence of architecture and design. (This is the case in all

technological revolutions, by the way.) Lacking roofs and walls, such architecture standing wide open to the world (i.e. made up entirely of reversible windows and doors) would alter the nature of existence. People would have nowhere to cower any more, nowhere to go to ground or take cover. All they would be able to do would be to offer one another their hands. They would no longer be subservient slaves; there would be no lord over them anymore to hide from or in whom to seek refuge. (Schiller is wrong when he claims that a good father must be *living* above the millions of brothers.) And there would no longer be any Nature threatening them and which they had to dominate. On the other hand, these houses standing open to one another would produce a hitherto unimaginable wealth of projects: Connected up to the network, they would be projectors of alternative worlds accessible to all human beings.

Such a method of building houses would be a dangerous adventure. Less dangerous, however, than hanging on in the ruins of the houses of today. The earthquake that we are witnessing forces us to embark on the adventure. Should it meet with success (and that is not totally out of the question), we would then be able to live again, process noise into information, experience something. If we do not embark on the adventure, we are, for the foreseeable future, damned to huddle between four walls under a roof full of holes in front of our television screens or to drive around in our cars, experiencing nothing.

The Non-Thing 1

Until recently, our environment consisted of things: houses and furniture, machines and motor vehicles, clothing and underwear, books and pictures, tins and cigarettes. There were also people in our environment, but science had largely made them into objects: Like all other things, they are measurable, quantifiable and easily manipulated. In short, the environment was the condition in which we existed. Finding our way around it was the same thing as distinguishing ourselves from artificial objects. No easy task. Is this ivy on the wall of my house a natural thing because it is growing and because botany, a branch of science, is concerned with it? Or is it an artificial thing because my gardener planted it in keeping with an aesthetic model? And is my house an artificial thing because designing and building houses is an art, or is it natural for people to live in houses just as it is for birds to live in nests? Is there any sense at all in wanting to distinguish between nature and culture when it comes to finding your way around the world of things? Should one not resort to other 'ontological' criteria – for example, by distinguishing immovable from movable things, apartments from appurtenances? This too creates difficulties. A country would appear to be an immovable thing, but Poland has moved further west. A bed would appear to be movable, but my bed has moved less than Poland has. Any catalogue of the world of things, whatever criteria are used to set it up – e.g. 'animate–inanimate', 'mine–yours', 'useful–useless', 'near–far' – is bound to have grey areas and gaps. It is no easy matter knowing your way around things.

And yet, as we are acknowledging with hindsight, it was rather cosy living in a world of things. Of course, one did have what could be called epistemological difficulties, but one knew more or less what one needed to do in order to be able to live. 'To live' means to proceed towards death. On the way, one

came across things that blocked one's path. These things called 'problems' had therefore to be removed. 'To live' then meant: to resolve problems in order to be able to die. And one resolved problems either by transforming intractable things into manageable ones – this was called 'production' – or by overcoming them – this was called 'progress'. Until eventually, one came up against problems that could not be transformed or overcome. These were called 'last things', and one died of them. This was the paradox of living surrounded by things: One thought one had to resolve problems so as to clear the way to death, so as to 'escape from circumstances', and it was the unresolved problems one died of. This does not sound very pleasant, but it is basically comforting. One knows what to hold on to in life – i.e. things.

Unfortunately, this has changed. Non-things now flood our environment from all directions, displacing things. These non-things are called 'information'. 'What nonsense,' one is tempted to say. There has always been information, and, as for the meaning of the word *in-formation*, it has to do with 'form in' things. All things contain information: books and pictures, tins and cigarettes. One has only to read things, 'decode' them, to bring the information into the open. It has always been like that; there is nothing new in it.

This objection is totally without substance. The information that now floods our environment displacing the things in it is of a kind that has never existed before: It is immaterial information. The electronic pictures on the television screen, the data stored in computers, all the reels of film and microfilm, holograms and programs, are such 'soft' ware that any attempt to grasp them is bound to fail. These non-things are, in the true sense of the expression, 'impossible to get hold of'. They are only open to decoding. Of course, as with old-style information, they also appear to be inscribed within things: in cathode-ray tubes, celluloid, micro-chips, laser beams. But although this sounds 'ontological', it is an 'existential' illusion. The material

basis of new-style information is negligible from the existential point of view. Evidence in support of this is the fact that hardware is getting cheaper and cheaper and software more and more expensive. The vestiges of materiality still adhering to these non-things can be discounted by looking at the new environment. The environment is becoming ever softer, more nebulous, more ghostly, and to find one's way around it one has to take this spectral nature as a starting-point.

But it is not even necessary to be fully conscious of the new nature of our environment. We are all imbued with it. Our existential concerns are shifting before our very eyes from things to information. We are less and less concerned with possessing things and more and more concerned with consuming information. Not just another piece of furniture or article of clothing but another holiday trip, an even better school for our children, another music festival – these are what we want. Things start to recede into the background of our area of concern. At the same time, a larger and larger section of society is engaged in the production of information, of 'services', of management, of systems, and a smaller and smaller section is involved in producing things. The working classes, those producers of things, are becoming a minority, and managers and apparatchiks, those producers of non-things, form the majority. Bourgeois morality based on things: The production, accumulation and consumption of things give way to something new. Life in an environment that is becoming immaterial takes on a new complexion.

One can object to this picture of change on the grounds that it does not take into account the mountain of junk accompanying the advent of non-things. This objection is without foundation: The junk proves the demise of things. What is happening is that we feed information into machines so that they spew out such junk in huge quantities and for next to no cost. This throw-away material, all those lighters, razors, pens, plastic bottles, are not true things; one cannot hold on to

them. And just as we get better and better at learning how to feed information into machines, all things will be transformed into the same kind of junk, even houses and pictures. All things will lose their value, and all values will be transformed into information. 'Revaluation of all values'. This is also by way of a definition of the new imperialism: Humanity is becoming dominated by those groups who have control over information, be it the construction of atomic power stations and weapons, aeroplanes and motor vehicles, or genetic engineering and management systems. Such groups sell this information at inflated prices to a dominated humanity.

That which is happening before our very eyes, this displacement of things to the outer limits of our concern and this focus of our concerns on information – is without precedent in history. So it is very unsettling. If we wish to find our way around it, despite the lack of precedents, we must look for some parallel. Otherwise, how are we supposed to try and imagine how we shall have to live in such an immaterial world? What will a human being be like who is not concerned with things, but with information, symbols, codes and models? There is one parallel: the first Industrial Revolution. At that time, concerns shifted from animate nature, cows and horses, farmers and artisans to things: machines, the products of machines, the labouring masses and capital, and so arose the 'modern' world that was, until very recently, the norm. At that time, one could claim with some justification that a farmer in 1750 BC had more in common with a farmer in AD 1750 than the latter had with an industrial worker, albeit his son, in 1780. Something similar is true again today. We are closer to a worker or citizen of the time of the French Revolution than to our children – yes, those children playing with electronic gadgets. Of course, this parallel may not make the current revolution any less unsettling, but it may help us to get a hold on things.

We will in fact come to realize that our attempt to get hold of things in life is not exactly the rational modus vivendi we

were inclined to think it was, but that our 'objectivity' is something relatively recent. We will come to realize that one can also live differently: perhaps better even. Besides, 'modern' life, life surrounded by things, is not the absolute paradise our ancestors perhaps thought it might be. Many non-Western societies in the Third World have good reason to reject it. If our children too are starting to reject it, this is not necessarily cause for despair. On the contrary, we must try and imagine this new life surrounded by non-things.

Admittedly, this is no easy task. This new human being in the process of being born all around us and within us is in fact without hands. He does not handle things anymore, so in his case one cannot speak of actions anymore. Nor of practice, nor of work for that matter. The only things left of his hands are the tips of his fingers, which he uses to tap on keys so as to play with symbols. The new human being is not a man of action anymore but a player: *homo ludens* as opposed to *homo faber*. Life is no longer a drama for him but a performance. It is no longer a question of action but of sensation. The new human being does not wish to do or to have but to experience. He wishes to experience, to know and, above all, to enjoy. As he is no longer concerned with things, he has no problems. Instead, he has programs. And yet he is still a human being: He will die and he knows it. We die of things like unresolved problems; he will die of non-things like program errors. If we think of him along these lines, he comes closer to us. The advent of the non-thing in our environment is a radical change, but he will not be able to alter the basic mode of existence, being unto death. Whether death is seen as the last thing or as a non-thing.

Since human beings have been human beings, they have been handling their environment. It is the hand with its opposable thumb that characterizes human existence in the world. This hand characteristic of the human organism grasps things. The world is grasped, by the hand, as being made up of things. And not just grasped: The things grasped by the hand are possessed so as to be transformed. The hand in-forms the things grasped by it. Thus the human being is surrounded by two worlds: the world of 'nature' (of things that are to hand and to be grasped) and the world of 'culture' (that of handy, in-formed things). Until quite recently, one was of the opinion that the history of humankind is the process whereby the hand gradually transforms nature into culture. This opinion, this 'belief in progress', now has to be abandoned. It is in fact becoming more and more apparent that the hand does not leave in-formed things, as it were, alone but that it continues to wave them about until the information contained within them is worn down. The hand consumes culture and transforms it into waste. The human being is not surrounded by two worlds, then, but by three: of nature, of culture and of waste. This waste is becoming more and more interesting: Whole branches of knowledge such as ecology, archaeology, etymology, psychoanalysis, are concerned with studying waste. And it turns out that waste returns to nature. Human history, then, is not a straight line leading from nature to culture. It is a circle turning from nature to culture, from culture to waste, from waste to nature and so on. A vicious circle.

To be able to break out of this circle, one would have to have non-consumable, 'memorable' information at one's disposal. Information that the hand could not wave about. But the hand waves all things about; it tries to grasp everything. Non-consumable information must therefore not be stored in

things. A culture without things would have to be produced. If this was successful, there would be no more forgetting; then human history would in fact be a linear progression. An ever-growing memory. Today we are witnessing the attempt to produce such a culture without things, such an ever-growing memory. Computer memories are an example of this.

A computer memory is a non-thing. Similarly, electronic images and holograms are non-things. These are non-things simply because they cannot be held in the hand. These are non-things because they are non-consumable information. It is true that these non-things are for the moment trapped within things like silicon chips, cathode-ray tubes or laser beams. But Hermann Hesse's *Glass Bead Game* and similar works of futur-ology make it at least possible to imagine the liberation of non-things from things. The liberation of software from hardware. In fact, we do not need to go in for futurological fantasizing: The lack of solidity of the culture from which things are increas-ingly absent is already a daily experience. The things around us are contracting (what is called 'miniaturization') and are getting cheaper and cheaper, and the non-things around us are expand-ing (what is called 'information'). And these non-things are ephemeral and eternal at the same time. They are not to hand, and yet they are handy: They are memorable.

In such a situation, there is nothing for the hands to get up to or do. As this situation is impossible to grab hold of, noth-ing in it is capable of being grasped, and nothing can be handled. In it, the hand – the grasping and productive act of handling – has become redundant. Whatever can still be grasped and produced is done automatically by non-things, by programs: by 'artificial intelligences' and robotic machines. In such a situation, the human being has been emancipated from grasping and productive work; he has become unemployed. Unemployment today is not an 'economic phenomenon' but a symptom of the redundancy of work in a situation without things.

The hands have become redundant and can atrophy. This is not true, however, of the fingertips. On the contrary: They have become the most important organs of the body. Because in the situation of being without things, it is a matter of producing and benefiting from information without things. The production of information is a game of permutations using symbols. To benefit from information is to observe symbols. In the situation of being without things, it is a matter of playing with symbols and observing them. To program and benefit from programs. And to play with symbols, to program, one has to press keys. One has to do the same to observe symbols, to benefit from programs. Keys are devices that permutate symbols and make them perceptible: *viz.* the piano and the typewriter. Fingertips are needed to press keys. The human being in the future without things will exist by means of his fingertips.

Hence one has to ask what happens existentially when I press a key. What happens when I press a typewriter key, a piano key, a button on a television set or on a telephone. What happens when the President of the United States presses the red button or the photographer the camera button. I choose a key, I decide on a key. I decide on a particular letter of the alphabet in the case of a typewriter, on a particular note in the case of a piano, on a particular channel in the case of a television set, or on a particular telephone number. The President decides on a war, the photographer on a picture. Fingertips are organs of choice, of decision. The human being is emancipated from work in order to be able to choose and decide. The situation of being unemployed and without things makes his freedom of choice and freedom of decision possible.

This freedom of fingertips without hands is rather unsettling, however. If I hold a revolver against my temple and pull the trigger, I have decided to take my own life. This would appear to be the height of freedom: I am able to free myself from any predicament by pulling the trigger. But in reality,

with this pulling of the trigger I set in motion a process that is pre-programmed in the revolver. I have not, as it were, made a 'free' decision, but I have made a decision within the limits of the revolver program. And the typewriter program, the piano program, the television program, the telephone program, the American administrative program, the program of the camera. The freedom of decision of pressing a key with one's fingertips turns out to be a programmed freedom. A choice of prescribed possibilities. I choose according to the regulations (outlined in the manual).

It looks, accordingly, as though the society of the future without things would be split into two classes: those programming and those being programmed. Into a class of those who produce programs and a class of those who behave according to programs. Into a class of players and a class of puppets. This is to look at things from too optimistic a point of view. Because what those programming do when they press keys in order to play with symbols and produce information is the same movement of the fingertips as the one carried out by those being programmed. They too decide within a program that could be called the 'metaprogram'. And the players with the metaprogram in turn press the keys of a 'metametaprogram'. And this regression from meta- to meta-, from the programmers of programmers of programmers, proves to be infinite. No: The society of the future without things will be classless, a society of programmers who are programmed. This, then, is the freedom of decision made available to us by the emancipation from work. Programmed totalitarianism.

Mind you, an extremely satisfactory totalitarianism. Since the programs are patently getting better and better. That means that they contain astronomical numbers of possibilities to choose between. Numbers that go way beyond the human capacity for making decisions. So that I never, while making decisions, pressing keys, come to the limits of the program. The keys at my disposal are so numerous that my fingertips

can never touch all of them. Hence I get the impression that I am making completely free decisions. The totalitarianism doing the programming, once it has realized itself, will no longer be identifiable by those participating in it: It will be invisible to them. It is visible only in the embryonic state it is in today. We are perhaps the last generation to be able to see the way things are going.

We can see this because for the time being we still have hands with which we can grasp things so as to be able to handle them. Hence we can see the approaching totalitarianism doing the programming for what it is: a non-thing, since we can't grasp it. Perhaps, however, this inability to grasp the state of things shows how 'outdated' we are? For, after all, is not a society emancipated from work, believing that it can make free decisions, the kind of utopia that has always beckoned to humanity? Perhaps we are approaching the fulfilment of the ages? In order to be able to judge this, one would have to make a closer analysis of the term *program*, this key term of today and tomorrow.

Carpets

The cave, the womb of the mountains, is our dwelling. However tall, however functional, however open they may be, our buildings are, and remain in spite of everything, imitations of caves. The more comfortable our rooms, the more similar they are to caves. Our troglodytism is confirmed on the one hand by history and on the other by depth-psychology. Is the cave really the original habitat of human beings? The answer depends on the meaning we give to the word *origin*. The caveman is a descendant of those who lived in nests. The cave is only a stage on the journey from the nest towards the coming into being of humanity. Because 'origin' means something different in the case of human beings than in the case of horses, for example. There is in fact an original horse, Eohippus, but no truly original human being. Neither a nest (tent) nor a cave (house) is a natural human dwelling. Nothing human is natural. That which is natural about us is inhuman. Nevertheless: A nest and a cave, even if they are human, are opposites.

The dialectic between nest and cave, between steppe and river, between herdsman and farmer, between tent and house, is at issue here. In other words, what is at issue is the carpet. The carpet is to the culture of the tent what architecture is to the culture of the house. But it has flown out of the tent across the steppe and in through an open window of our dwellings. Now our floors have become the base for carpets. And carpets have turned into pretexts.

The first carpets known to us appear in Egypt in the sixteenth century BC as a contribution by the plains of Asia to the marvellous architecture of the river. Carpets triumph on the banks of the great rivers of China and India, brought from Mongolia by Genghis Khan and Kublai Khan. The greater Persian empire of Tamerlane can be seen as a synthesis

between the land of Two Rivers, the steppes of Central Asia and the Pamirs. A synthesis given insufficient attention in our philosophy of history. The wonderful Peruvian carpets are never mentioned in it because, like everything pre-Columbian, they introduce confusion into our categories.

The Gothic art of carpet-making is a distant rumbling of the desert storm, originating in the Russian steppes and the Sahara, that threatens feudal castles, projecting its shadows onto their walls. The Gobelin tapestries of the eighteenth century slipped through the gaps in the ruinous castles of the West as messengers from Persia and China. As the last remnants of the bold blast across tundra and taiga, they now whisper timidly on the Rococo walls of a doomed French aristocracy. And if it is correct, if all our carpets are raging storms that have slipped through gaps in the walls to whisper around us, how do we explain the renaissance in carpets that we see in so-called art exhibitions? Because if this is correct, then surely the carpets are not just messengers, but heralds of a storm. Egyptian carpets bear witness not only to the whirlwinds of Sinai but also to Akhenaten. Gothic carpets bear witness not only to the Seljuk hordes but also to Simone Martini and even to Luther. The Gobelin tapestries witness not only the Thirty Years' War between the faiths but also the French Revolution and the Industrial Revolution. What are the carpets of today testament to? What storms do they bring and project against our walls to herald what coming whirlwind?

The answer is concealed within the carpets themselves. They are weavings whose weft conceals and covers up the warp. In a well-knotted woollen carpet, the fact that its warp is nothing but ordinary string is concealed by means of high-quality knots in the wool. The attitude of one knotting a carpet is the opposite of that of a weaver of cloth. Our clothes are results of a weft that does not deny the warp but raises it to the surface. Carpets, on the other hand, are the results of a knotting that denies and conceals its own warp. This description of the

techniques of weaving and of knotting is intended to express the conspiratorial, even deceitful, nature of the affair. Knotting carpets is a campaign on the part of the surface against the warp, against its own base. That is why the carpet-maker has recourse to designs that have been worked out exactly in advance and that are fully aware of the fact that they are only pretexts. Carpet patterns that are laid down in precise detail on paper and other disposable material, and that are followed in the course of knotting carpets, are works of art intended to be thrown away. There can be no spontaneous movements in making carpets. Every single knot has been thought out in advance. Knotting itself is not a fluid process but a jerky one, every leap of which is prescribed within a provisional mosaic. Thus, for example, green, then yellow, then red and then blue knots are knotted onto the warp in that order, and the prescribed form only becomes visible after completion of the process of leaps. The static impression that carpets give is a deception: It is the result of a leaping, seemingly random technique based in turn on a static design.

The attempt to put ourselves into the shoes of a carpet weaver is destined to fail. What he does is recommended by psychologists today as psychotherapy, but the recommendation is questionable. It is true that the carpet weaver appears to manipulate woollen yarn and styles of weaving with his fingers, but he does so in a paradoxical way. He engages with the material by following a design that is prescribed for him, making this design appear so as to cover up the material. The carpet weaver does not aim to reveal what he has done but to conceal it. He aims at an appearance, and that means not just beauty but deceit. He aims to conceal the truth by means of beauty. He is committed to presenting Schopenhauer's world as representation as opposed to that philosopher's world as will. In short, to hanging the carpet so as to cover the wall.

This investigation of the carpet can produce an answer to the question 'Whence does the wind blow it to us, and whither

is it blowing us?' It is a cold wind blowing towards us from those regions where the truth was questioned. And it is blowing towards those realms where beauty and appearance conceal the fact that we have lost the truth. Carpets are hung on walls so as to conceal cracks in the wall. This is not the worst way of describing the situation of culture today.

Pots

And the Lord spake: 'Like a potter's vessels shall the peoples be broken to pieces.' The intention of this essay is to interpret this ominous prophecy. It can be interpreted because it says many things. Unambiguous statements cannot be; they are not open to interpretation. The sentence to be interpreted is biblical, the Bible is open to multiple interpretations, and this is what theologians live off. Hence this essay belongs to a long tradition, but it is not necessarily meant to be read in the spirit of theological disputes.

There is an obvious interpretation for the sentence quoted: Each one of us has broken a pot at least once, but not one of us has ever broken a people. For the Lord, however, peoples are what pots are for us, and He threatens to demonstrate this. The interpretation I shall attempt here will represent a totally different point of view. It will start from the premise that, in the sight of the Lord, pots are something different from what cooks consider them to be. In fact, in the sight of the Lord pots resemble more those forms that the Ancients referred to as 'immutable Ideas'. This is the starting-point for bringing the following ominous prophecy to life: 'You along with all your allegedly immutable Ideas shall be broken to pieces.'

Pots are considered to be empty forms. They are that. It is not a matter here of reducing a difficult subject to something as simple as a pot. Quite the contrary: It is a matter here of looking at 'pure form' phenomenologically; this, then, is to look at it as a pot. In other words: The question of what form is is not being simplified here, but the question of what a pot is is getting more and more complicated. A pot is a vessel, a tool to be grasped and held. It is an epistemological (phenomenological) tool. For example: I take hold of an empty pot and hold it under the water fountain. By doing this, I have given the pot content and the water form, and the water now

in-formed by the pot is included in the pot instead of flowing amorphously. This is a banal fact, but in fact no epistemological theory, and no theory of information, has so far come to terms with it.

Here is one example of the difficulties arising from this: It is well-known that de Gaulle had 'une certaine idée de la France', even if he unfortunately left open the question of what his idea of France was. Did the General perhaps go into a potter's studio and look around until he found a pot into which he could pour France? Or did he buy a particularly beautiful pot and then try to pour France carefully into it? Or, on the other hand, did he shape a pot himself and then hold it under the French fountain so as to catch France?

These are unsettling questions, as they concern not only the General but the whole proud edifice of science. What am I doing when I formulate the laws of nature mathematically (create for myself 'une certaine idée' of natural phenomena)? Do I look among the available algorithms until I find one into which the phenomenon fits? Or do I choose a particularly beautiful one (for example, Einstein's equation) and then carefully try to pour phenomena into it? Or do I cobble an equation together and then go fishing for phenomena with it? The whole gigantic crystal palace of algorithms and theorems that we call science stands on pillars built of answers to such questions. And these pillars are shaky. The Lord's threat to break the peoples like a potter's vessels takes on a new significance.

Perhaps a consideration of the production of a pot can help here? A pot is a hollow space, and this sounds like something negative. A hollow space arises when something is taken out of a full one, is abstracted. With the help of a shovel, for example. A pit is such a hollow space. Pots too can be made in this way, for example by scooping out a ball of clay with the thumb. But pottery was probably invented in quite a different way. At first, one most likely clasped the fingers of both hands together so as to make a hollow space to catch drinking water. Then,

instead of fingers, one intertwined twigs – hence the origin of baskets (and weaving in general). As, however, baskets cannot hold liquid, one lined them with clay. Finally, people burnt these waterproof baskets either by chance or intentionally (we know how much chance and intention condition one another), and in this way the beautiful original pots with a black geometric pattern on a red background (the traces of the burnt twigs) were produced.

This diversion into the technology of ceramics has not been all that productive. It has produced the result that empty pots, pure Ideas, pure forms, can be abstractions as well as intentionally produced, interwoven constructs. For someone who thinks formally (a mathematician, for example), this does not make any clearer what he is actually involved in. Whether it is a matter of weaving forms to catch phenomena, or of abstracting forms from phenomena, or even of playing with empty forms (like soap-bubbles). One thing is clear about this, however: Whether woven or hollowed out, empty vessels can never be broken. There is nothing about them that can be broken. Take the empty vessel: '1 + 1 = 2'. Irrespective of whether it is a woven construct to catch countable things or an abstraction made out of counted things, it is without time and space. There is no point in asking it whether it is also true at 4:00 p.m. in Vladivostok. This is how pots must appear in the sight of the Lord. And they shall in any case be broken into pieces by Him.

If one looks at the world from a potter's point of view, one sees behind all the phenomena and throughout all the phenomena the pots that hold and in-form these phenomena. Behind the apple the sphere, behind the tree-trunk the cylinder, behind the female body several geometric figures, and, recently, behind apparently formless, chaotic phenomena (such as clouds and rocks) so-called 'fractal' forms. This potter's way of seeing, this X-ray vision, for which phenomena are fleeting veils concealing eternal forms, is equivalent to a

theoretical view. And this view has in our day developed a new pottery technology, an electronic ceramics. We have pieces of equipment that display empty, but coloured, so-called artificial images made of algorithms on computer screens. Anyone looking at such images has in front of them the empty, unbreakable vessels hiding behind phenomena.

If Pythagoras could see the same empty form behind the musical octave and behind the triangle, then this was a mystical view. If Plato saw the eternal Forms of beauty and goodness in theory through phenomena and retrieved them from amnesia, then this was an act of illumination. Yes, even Galileo, when he recognized the simple formula of free fall behind the formless movements of heavy bodies, and those others who were able to make out the relatively simple chemical formulae from the chaotic mass of materials, they all still thought they had partly uncovered the Lord's building plan behind phenomena. But what about those who sit at computers, playfully displaying empty forms on their screens and then waiting until others fill these empty vessels with contents? And what about those who design so-called 'virtual spaces' in order to create alternative worlds out of them? They shall be broken by the Lord along with their pots.

The interpretation of the prophecy being offered here is the following: The peoples of the computer, these producers of pots, shall be broken along with their empty vessels. This may not sound very biblical, but it is biblical enough to give one the creeps and should be mentioned in hushed tones at all conferences on things like 'Digital Imaging', 'Cyberspace' and 'Artificial Simulation and Holography'. Interpreted in this way, the prophecy, as with this entire essay on pots, is talking about hollowness. Empty pots are hollow vessels. Eternal Ideas are pure, hollow thoughts. Mathematical formulae are hollow propositions without content. The purest of all Ideas, the highest of all Forms, is the Godhead. Because pure Ideas are hollow, they are unbreakably eternal. The Lord is eternal. And

this is what the computer people, these potters of form, are beginning to see. They are acting like the Lord (*sicut Deus*) when they design empty forms, fill them with possibilities and thus create alternative worlds. They shall be broken by the Lord.

By using the word *hollow*, one gets to the root of things. From 'hollow' there come 'Hale' and 'Hell', as one can see from the English 'whole' and 'hole'. By using the word *hollow*, you are talking of the Whole. For quite a long time, science, by thinking formally, has been disclosing what is behind phenomena, and it sees the hollowness (the curved space of mutually intersecting fields of possibility) behind them. But only recently have we begun to compute alternative contents out of this hollowness. Only recently have we begun to learn what pottery is all about: about producing empty forms in order to in-form what is amorphous. About what the Lord was doing on the first day of Creation. This is the real Big Bang: that we have finally learnt how to make pots. And the prophecy says: We shall be broken by the Lord along with our pots, before we are able to do it as well as, or even better than, Him.

This is how it is with interpretations. They are put forward in order to be falsified – i.e. in order to provoke new, equally falsifiable interpretations. This final statement can be read as a prayer in view of the ominous prophecy that has been the subject of this interpretation.

Shamans and Dancers with Masks

If one feeds the equations that science uses as a means of expression into a computer, then the scientific image of the world will appear on the screen. In fact, this will be in the shape of a network of intersecting and overlapping connections. In some places, the connections will condense and form pockets. These troughs within the fields of the network are called 'matter', while the connections forming them are called 'energy'. If one 'animates' this computer image (makes it into a film), it is possible to observe the pockets bulging out of the networks of connections becoming more and more complex in various places, then levelling out again and finally disappearing without trace into the network. The 'happy ending' of the film consists of a network of connections extending amorphously in all directions. This can be called 'heat death'. One of these troughs can be identified as 'our sun'. In this valley, one recognizes a sub-valley as representing 'our earth'. If one takes a closer look at this sub-valley, one can make out a large number of tiny pockets: the biomass enveloping the earth. If one directs one's attention towards these splashes, we ourselves become visible among the small, fleeting wavelets.

If we recognize ourselves in this way as temporary pockets of force fields intersecting one another, then the whole of traditional anthropology goes out of the window. In this case, we are in effect knots of relations (connections) without any core (any 'spirit', any 'I', any 'self', indeed without anything at all to 'identify' ourselves by). If we unravel the knots of relations that we are made up of, then there is nothing left to hold on to. To put it another way: The 'I' is then that abstract point at which concrete relations intersect and from which concrete relations begin. We can then of course 'identify' ourselves with these knots of relations within ourselves: for example, as a heavy body (nodal intersection in the

electromagnetic and gravitational fields), and as an organism (nodal intersection in the genetic and ecological fields), and as a 'psyche' (nodal intersection in the collective psychological field), and as a 'person' (nodal intersection in the mutually intersecting social and inter-subjective fields). Instead of a 'person', one can also talk of a 'mask'. What was formerly called 'identification of the self' can now be better identified by reference to a mask (or to several interchangeable and super-imposable masks).

Thus the term *mask* is returned to its original existential meaning. One is what one is only by wearing (dancing in) a particular mask, by the other members of the tribe recognizing the mask and giving it its due. Originally, there were relatively few masks: those belonging to the shaman, the hunter, the homosexual. Later on, masks became more numerous; today they can be worn on top of one another. One can, for example, dance as a bank manager and wear underneath one's mask that of a connoisseur of art, a bridge player and a father. If one peels off one mask after another, then nothing is left at the end (just like an onion). Existential analysis puts it thus: The 'I' is that which one says 'you' to.

If one sees society (the field of inter-subjective relations) in this way – as an organization hiring out masks – then it represents a network within which physical, biological, psychological (and other) nodes are captured in the shape of masks so as to be condensed into 'persons'. It is, then, a question of producing these masks and applying them to the multitude of relations in the network. Here the design of masks actually becomes a political matter. This is clear in the case of an Amazonian tribe: How is the design of the shaman's mask produced, and in what way is the mask applied to the young man approaching puberty so that he is recognized by everybody as a shaman and may identify himself as such? In a society as complex as so-called 'post-industrial' ones, this process is less apparent. It is, however, simple enough to

formulate this question so that most political categories are plunged into total confusion.

It is not very likely that one will get much of an answer from the Indians of the Amazon if one asks them about this. They will attribute the design of a mask to superhuman powers (e.g. an ancestor in the form of a leopard) and will explain its application by reference to a sacred tradition. This is an ideology, one no less credible than our own ideologies but one that is nevertheless alien to us. Our own ideologies (particularly the Judeo-Christian and Humanistic ones) presuppose a core of 'I' that insinuates itself into the available masks and conceals itself within them, and this makes it more difficult to understand the design of the mask than invoking an ancestor in the form of a leopard does. Hence there is nothing left for it but to attempt to step back a little from the field of inter-subjective relations and look at masks from the outside – an impossible task, for, without a mask, 'we' do not exist and are therefore not in a position to recognize masks. (This used to be referred to as the 'dialectic of the unhappy consciousness'.)

There is, however, one thing we can say: As ladles that are, as it were, plunged into the stew of relations so as to serve up persons, masks themselves somehow emerged from the stew; they are themselves inter-subjective forms. (The bank manager's mask has not floated down to society from some heaven of a higher vocation or profession; vocation and profession follow from the mask.) Thus the question of the design of masks is an inter-subjective issue. This means: That which I am, I only became through a collective 'dialogue'. The conclusion to be drawn from this is: The 'I' is not only the wearer of a mask but also a designer of masks for others. Thus I 'realize' myself not only whenever I dance in masks, but equally whenever I, together with others, design masks for others. The 'I' is not only that which one says 'you' to, but also that which says 'you'. Of course, I can only design masks while wearing a mask. This is not a satisfactory answer to the question of the design of

masks, but at best the starting-point for further questioning. It is only this process of asking questions that differentiates us from the Indians (including those who dance around us or who get their masks from watching television). *Design* means, among other things, fate. This process of asking questions is the collective attempt to seize hold of fate and, collectively, to shape it.

The Submarine

If Modernity represents the shattering, fragmentation and
breaking up of the medieval way of thinking by means of
which the Catholic Church pointed minds towards the sign of
things to come, then the years beginning with the Industrial
and French revolutions and ending with the Submarine point
towards a reuniting of the human intellect under the sign of
solipsism. Based on what we have inherited in the way of the
documentary evidence and archaeological remains from that
eventful period, plagued as it was by wars, I shall attempt to
illustrate which areas of science, philosophy, art and religion
were the chief influences that led inevitably to the creation of
the Submarine. The physical sciences dissolved matter and
energy into a fog of mathematical and logical symbols; the
biological sciences reduced life and its manifestations to a mass
of abstract principles; the social sciences identified society as
an organization of laws that can be expressed simply in terms
of statistical mathematics. Religions identified God as an
abstract idea and the Devil as at best an allegory, if not a myth.
The arts became more and more abstract; they presented and
represented nothing, they worked in a vacuum. Philosophy
abandoned the *Ding an sich*, and thus the search to discover the
way things really are, and limited itself to formal statements of
pure logic, pure mathematics and pure grammar or to discus-
sion about Existence, to the exclusion of Being as such. In other
words: The sense of reality disappeared from all areas of intel-
lectual activity; the world turned into a dream, the dream of an
ideal world (at the beginning of the nineteenth century) being
distorted into a nightmare (around the middle of the twenti-
eth). The world turned into a dream scenario, but this was not
accompanied by activity trailing off into resignation; on the
contrary, there has not been a period that has seen so much
feverish activity, fighting, painting, writing or thinking.

Humanity did not resemble so much a peaceful dreamer as someone tossing and turning, their sleep disturbed by bad dreams. Around the middle of the twentieth century, they were rudely awakened from their troubled sleep, or – to put it another way – their dream became real. I only want to talk about the outward form of this awakening; we shall leave until later an account of its significance and consequences.

Research in physics in that period managed to prove the fundamental unity of matter and energy in a purely mathematical way and without the need for any deeper insight or display of mysticism. The consequence of this, it goes without saying, was that unlimited amounts of energy suddenly became available, and unlimited amounts of matter offered themselves for destruction. For the fact that the same discovery made it possible to condense matter from energy – thus not only to destroy it but to build it up as well – is a much later development. There was only one uncertain limitation upon this limitless ability to destroy: the high financial cost of launching destruction. This at first precluded the possibility of any one individual annihilating the world; that remained the prerogative of those governments that had the necessary funds available. Over the course of time, however, it became more and more apparent that the cost of destroying the world was going to drop considerably; in other words, the list of potential world-destroyers was broadening to include more and more governments, economically powerful institutions such as large companies and banks, and, in the end, individuals. There were no moral barriers impeding this development (after all, if the world was a dream, thus ethically neutral, one was free to go ahead and destroy it), and it must have seemed to people in the middle of the twentieth century that the eventual destruction of the world of things was only a question of time, in fact a period to be measured in years rather than decades. This is the period that saw the establishment of that unique phenomenon that we have come to call the 'Submarine'.

The correspondence between scientists and philosophers, artists and theologians, who created this Noah's Ark to escape the Flood has survived in part. To illustrate the prevailing intellectual climate of the times, I quote from one of those historic letters. 'I am aware', it says,

> that my training as a chemist does not qualify me in the slightest to be a saviour of humanity. I am myself unsure about the motives inducing me to participate in our insane experiment to stand out against an inescapable development. The human race appears to be condemned to destruction as a result of their mistakes and wrong-doings; and it sometimes seems to me that our attempt to suspend this sentence is highly sinful.

I could go on to give many other examples, but I think that I have provided adequate evidence of the yawning gulf between logic and ethics, knowledge and belief, at that time, and of the despair that led to such a gulf. What strikes me as one of the greatest achievements of those seventeen men and women who gave up human society in order to save it is that they united knowledge and belief once again in their own persons and thus found their way back to reality.

The external circumstances are so well known that I need only mention them briefly: Seventeen prominent men and women from the worlds of science, art and religion misappropriated public funds, putting them in a position to build what was for the time a gigantic submarine or, rather, to build it in separate parts and assemble it in an abandoned shipyard in Norway. This submarine made them materially independent thanks to a nuclear reactor that provided an unlimited supply of energy, and biologically independent thanks to a laboratory based on seaweed that provided an unlimited supply of food, and intellectually independent thanks to radio and television sets that guaranteed permanent intellectual contact with the

rest of humanity. In this submarine, they installed equipment that is best thought of under the common heading 'weapons representing a material and intellectual threat to, and thus a means of dominating, humanity'. And they surrounded the vessel with armour made out of negative material which they believed to be completely impenetrable. For reasons of greater security, they anchored this craft at the bottom of the Pacific Ocean in the vicinity of the Philippines with the intention of using their position there to force humanity into military and intellectual disarmament. It is one of the most tragic jokes in history that the failure of this project and the destruction of these people was precisely the thing that led to its successful outcome, making them as it were the saviours of humanity in reverse. We know that all they succeeded in doing was to cause the world powers to unite against them and to push humanity not just onto military alert but into a moral panic as well. A new peace resulted from this cosmic push. You can, if you like, draw parallels between this event and what happened at Golgotha, but in the present case I have decided to keep to the facts just as they stand.

I will not go into the problems that stood in the way of the construction and equipping of the submarine. They were solved and so are not a problem for us anymore. I shall, however, touch on the problems that these people proposed to solve by means of their bid to dominate the world and that led to their downfall, as it was bound to do. They are eternal problems which probably do not admit of any solution, and, seen in this light, the submarine was only one of the innumerable experiments to bring about utopia. But the way in which the seventeen set the problems out and attempted to solve them shows these people to be figures of considerable relevance who are still the subject of argument even after so many centuries of human experience. Also, what makes this whole complex of questions so fascinating is the fact that all the material power in the world was for a time concentrated in the submarine, and

thus from the point of view of power politics nothing stood in the way of the proposed solutions being put into practice.

Dominating the material world proved to be the least of the problems to be overcome, and the task of those among the seventeen who were physicists and chemists very soon became a subsidiary one, as they had fulfilled their function. By means of rays that could be controlled very precisely, the submarine was able to threaten any human being anywhere in the world with instant death, and thus permanently terrorize every single individual without causing a general state of terror throughout humanity. In this way, the submarine achieved the total compliance of any person who was singled out and was only required to do any actual killing in the first few days, when it was a matter of proving the effectiveness of the rays. From this period right up until the general uprising of humanity, the domination of the earth by the submarine was completely uncontested, and the burden of governing humanity rested on the shoulders of those among the seventeen who were national economists, ethnologists, biologists, philosophers, theologians and artists. The records of proceedings that were probably made during sittings of the all-powerful committee were unfortunately lost during the sinking of the vessel, so we have no information as to the arguments and disagreements that no doubt took place in the submarine, and the submarine comes across as a collective super-brain, as an absolute ruler with his own thoughts and desires. The first proclamation to humanity decreed by the submarine after the seizure of power and carried by all the radio stations on earth in all languages gives some idea of where this brain stood on things. It read as follows:

In the cause of maintaining the earth as an inhabitable place for human beings, we have taken over the legislative and executive powers of the whole of humanity. In the exercise of this power, we shall be guided by the following

principles. First, the human being is made in the unique image of God. Second, the fact that people come together in groups conditioned by biology or economics has to be taken into account by the administration, but must not overshadow the fundamental uniqueness of the individual human being. Third, the administration has to build up and maintain the economic, legal, biological and educational principles by which the intellectual, moral and artistic approach of every individual human being to their god can be developed. However, it must not itself influence the particular approach.

As is well known, decrees then follow which dissolve all armies, consign all warships and fighter planes to destruction, destroy all nuclear weapons and provisionally maintain all the laws and regulations of the previous system of government.

As I indicated, this first declaration illustrates the fundamental attitude of the submarine towards the problem of world domination and already provides a hint as to the tragic ending of this reign of terror. It was obvious that all tendencies would unite against such an assault on the human spirit. The materialists – whether socialist or liberal – were up in arms straightaway at the first statement of the proclamation. The second point turned all the nationalists, blood-and-soil mystics and racial theorists into sworn enemies, not to mention all syndicalists, leaders of organizations for Christian workers, Moslem liberationists and anti-colonial Blacks. The first statement of the third point set all free-thinkers, independent philosophers and artists against one another; the second statement of the same point turned all the religions against one another. This declaration put in place the entire basis for a common agreement on the part of humanity to unite under the banner of a holy war against the submarine.

The crew of the submarine now began to put their ideas into practice from their position at the bottom of the Pacific.

On the economic level, they began to abolish the giant corporations – whether based on private capital or on state capitalism – and to replace them by competing small collective enterprises. At the same time, they abolished national frontiers and founded something called the 'natural common market'. By means of credit regulations (as banking was nationalized – i.e. made dependent upon the submarine), they attempted to turn economic activity in industry and agriculture over to wide-scale automation and thereby reduce working hours to a minimum. In this way, the crew of the submarine thought that they could turn every human being into a capitalist, a shareholder in factories where machines laboured. It has taken centuries for humanity to recover from the resulting economic chaos.

In the field of biology, the crew of the submarine tried to purify humanity by means of eugenics. I will not go into the innumerable tragedies brought about by the attempt to organize love on a rational basis. The automatic mixing of races into one human race was in no way promoted by this attempt; instead, though this was the intention, it was if anything impeded.

Psychology employed in the service of the submarine – i.e. propaganda carried by radio and the press intended to condition people to happiness – did not meet with the success expected of it. This may have to do with the still rather inadequate understanding of the psyche at the time, but also with the resistance shown by every single citizen to the propaganda put out by the submarine.

The attempts that were equally unsuccessful in the field of the arts, sciences and education – particularly in the field of education for belief – need only be mentioned in passing; they must be left to future investigations more substantial in scale.

What was to blame for the submarine's failure to dominate the world? It was reality that failed it, the very same reality

from which the twentieth century had distanced itself and no longer believed in. At the start of my observations, I attempted to prove that the twentieth-century human being was living in a dream world in which a walking-stick was an electromagnetic field or a cultural production or a manufactured object or a sexual symbol or a thing giving evidence of existence, living in a world in which it could in fact be anything except a walking-stick. All that the seventeen people in the submarine were doing was attempting to dream the dream to its conclusion. That is where the dream exploded and humanity woke up to reality; to put it rather irreverently, they recognized the godhead once more in the walking-stick. This awakening had an elemental force the likes of which had not been seen since the awakening to reality that took place in the third century AD. Everything that smacked of Modernity (i.e. of the Enlightenment), abstraction and logic were obliterated from the face of the earth, and the submarine was to be the first victim of this catharsis.

In future, let us try and analyze the consequences of this revolution of belief. So far, I have limited my account to the submarine, and I do not wish to end without emphasizing once more the tragic greatness of these human beings who ended up at the bottom of the Pacific Ocean. Seventeen men and women condemned themselves to the deep to save humanity from certain death. They were, and this goes without saying, still imbued with the prejudices and ideas of their age, and it equally goes without saying that they caused an immense amount of trouble. We, the children of a later and – we think – more enlightened age find it easy to condemn them, to make fun of them even. But they were at the same time the heralds of a new era. They represent the first attempt by humanity since the Middle Ages to combine belief and knowledge and art. The fact that this attempt failed because it was dominated by knowledge – that is by science – and not by belief, as in the case of the Gothic cathedrals, does not make

these people any less important; in fact it makes them more so. With this observation, let us leave the short-lived domination of the world by the submarine, that unsuccessful and, for that very reason, successful cathedral of knowledge.

Wheels

One of the most lasting consequences of Nazism is the way in which the swastika has been turned into a kitsch object. This is no small achievement given how deeply embedded the sign is in the human consciousness. So deeply embedded that the Atlantic is shallow in comparison: The swastika looks approximately the same in the cases of the Celts and of the Aztecs. This essay will attempt to reflect upon this sign, but first a note on methodology is called for.

One can look at things in at least two ways: by observing and by reading. If one observes things, one sees them as phenomena. In the case of the swastika, for example, one sees two crossing bars and one sees the ends of those bars bent at right angles. If one reads things, one presupposes that they mean something and attempts to decipher this meaning. (As long as one saw the world as a book, a *natura libellum*, and as long as one attempted to decipher it, a science without presuppositions was impossible. And since one has observed the world, instead of reading it, it has become meaningless.) If one now approaches the swastika by reading it, then one sees four spokes radiating from a hub that turn in the direction of the right angles, and the right angles begin to describe the circumference of a circle. From the point of view of reading, the sign expresses itself by saying: I am the wheel of the sun, and I am radiating.

At this point, the motivation for this essay must be admitted: If one observes the post-industrial situation, one is impressed by the slow but irreversible disappearance of wheels. They no longer tick away inside electronic equipment. Anyone wanting to progress no longer goes on wheels but on wings, and once biotechnology has overtaken mechanics, then machines will no longer have wheels but fingers, legs and sexual organs. Perhaps the wheel is just about to become a

circle and thus one among many equal curves. Before such a decadence of the wheel takes over, it seems advisable even at this late stage (and despite the trivialisation) to relate the deep incomprehensibility of the wheel to the image of the wheel of the sun.

The image points the way from the sign towards the signified, from the swastika towards the sun. It is a glowing disc, and it circles round the earth. In fact, it is only the upper semi-circle, that between rising and setting, that is visible; the lower one remains a dark secret. This eternal turning in a circle, eternally repeated in all its phases, is totally anti-organic. In the realm of the living, there are no wheels, and the only things that roll are stones and felled tree-trunks. And life is a process: It describes a line from birth to death, it is a becoming in order to pass away. But the wheel of the sun also contradicts death, as well as life: It mysteriously bends its setting back into its rising. The wheel of the sun overcomes life and death, and the whole world is visible under this wheel, because it is this wheel that makes it appear in the first place. And if one looks at it this way, it has the following appearance:

It is a scene in which people and things relate to one another – i.e. change their positions in relation to one another. The wheel of the sun, the circle of time, moves each and every thing back into its allotted position. Every movement is a crime committed by people and things against one another and against the eternal order of the circle, and time goes round in a circle in order to atone for these crimes and return people and things to the position allotted to them. Hence there is no essential difference between people and things; both are animated by the desire to sow disorder, and both are judged by time and with time for their wrong-doing. Everything in the world is animated, since it moves, and it must have a motivation in order to move. And time is both judge and executioner; it goes in a circle round the world, puts everything right and makes everything part of a wheel. In this atmosphere of crime

and punishment and eternal recurrence – in other words, under the sign of the wheel of the sun – human beings have lived out most of the period of grace granted to their existence on earth.

There have always been human beings who have attempted to rebel against the circling wheel of fate. All they have achieved has been to provoke fate even more. Precisely because Oedipus did not want to sleep with his mother, for that very reason he did so and had to tear out his eyes. This the Greeks called 'heroism'. The Pre-Socratics wanted to overtake the wheel on the outside – via the transcendent. They thought that, in order to be able to turn, the wheel must have a motivation, a mover. Without that which Aristotle worked out in his day in the shape of an Unmoved Mover behind time, this – in itself unmotivated – motivation, one cannot imagine the Western concept of God.

Long before the Pre-Socratics, however, there is evidence in Mesopotamia of a kind of heroism of quite a different type. Try and put yourself in the shoes of a Sumerian priest. There he was sitting on his tell attempting to decipher the circling world of wheels. He saw birth, death and rebirth; he saw crime and punishment; he saw night and day, summer and winter, war and peace, fat years and lean years; and he saw all these phases meshing with one another in a cyclical fashion. From these cycles and epicycles, the priest could read off the future, by means astrology for example, not to prevent them happening but to prophesy their happening. And suddenly, he had the incredible idea of building a wheel that would turn in the opposite direction to the wheel of fate. A wheel that, if placed in the Euphrates, would turn the waters round so that they would not flow into the sea but into channels. This is, seen from our point of view, a technological idea. But at that time and in that place, it was an incomprehensible breakthrough. The invention of the wheel broke through the magic circle of prehistory; it broke the power of fate. It broke its way into a

new form of time: history. If anything does, the invention of the water-wheel deserves to be called a 'catastrophe'.

Before getting carried away with the philosophy of it, we should not be prevented from following up the later development of the wheel. In other words, looking at that cart pulled by a donkey taking corn to the mill. This is a totally different scene from that of the heroic inventive priest. It comes in the middle of history and is closer to the Industrial Revolution than to Myth. For the concept of the vehicle wheel – i.e. the cartwheel – is entirely due to historical consciousness and could only arise where history is a lived experience. For instance:

Imagine taking the water-wheel out of its usual situation and giving it impetus. It would have to roll across an infinitely extended space for an infinitely long period of time, and this is after all precisely what we call 'history': an infinitely long, infinitely extended rolling motion. It turns out, however, that this is not the case; a motor is needed, the donkey that has to give the wheel continually renewed impetus to keep it rolling. How can we explain the fact that a vehicle wheel must be a 'motorcycle' and cannot be an 'automobile', cannot be a *perpetuum mobile*, cannot be something eternally motivated? The idea of the vehicle wheel on its own cannot explain this. The wheel is a circle, so it is always in contact with its orbit by means of a single point. As a point is without dimension, is Nothing, the wheel is never in contact with the reality it is rolling over and therefore should in no way be influenced by it. Nevertheless, it does in fact rub up against the treacherous repulsion of the world, and donkeys have to pull it in order to keep it rolling.

Consider how far away we have come, in discussing the problem of the vehicle wheel, from the mythical world of the wheel of the sun. And the basic difference between the world of Myth and ours is this: In the world of Myth, there can be no unmotivated movement. If something moves in it, this is because it has a motivation – i.e. because it is animated by a

motivation. In our world, on the other hand, movement calls for further explanation. Our world is inert, or – to put it more elegantly – the law of inertia explains all movement and all rest. Of course, there are, also in our world, movements that appear to be motivated. Our own, for example. Such abnormal movements are characteristic of living beings. The eighteenth century cherished a hope of explaining away the motivations of living beings as legends and of explaining living beings in terms of complex machines. This hope has never materialized, and yet the world of Myth is an animated world – living beings are all within it and are wheeled along by fate – while ours is an inert, inanimate world, even if living beings occur within it, and this inert world rolls on and on without motivation.

So how come vehicle wheels are always catching? Because a point is only Nothing in theory and because a wheel is only a circle in theory. In practice, a point is always elongated, and a circle is always slightly irregular. According to the law of inertia, wheels should in theory roll forever to infinity, but in practice they come up against friction, which puts a brake on them. However, this does not mean that we should abandon theory when building vehicle wheels. On the contrary, it means that we must, at the same time, build a theory of friction into the theory of inertia. With the cart pulled by the donkey, we are caught right in the middle of a contradiction between theory and observation, between theory and experiment – i.e. between thinking scientifically and thinking technologically.

The world has become inert and inanimate and at the same time treacherous and repulsive since, by the invention first of the water-wheel and then of the vehicle wheel, we have broken through the fateful wheel of the eternal recurrence of the same. But we can overcome the repulsive treachery of the inanimate world by means of the dialectic between theory and experiment and force it to act as a basis for a limitlessly rolling progress. The wheel of progress cannot move endlessly forward automatically because it is forced over and over again

to overcome the blind, unmotivated resistances of an inanimate world – e.g. the earth's attraction and the unevennesses of the surface. The wheel of progress needs a motor, and we ourselves are this motor, our own will. Hence the slogan of the triumphant Industrial Revolution: 'If your strong arm it should will, all the wheels must stand still' or: 'We are the drivers of all the wheels, the living God of a dead universe.'

Unfortunately, not for long. It has recently turned out to be the case that the repulsive frictions that obstruct the wheel of progress can in fact be overcome and that progress then starts to roll automatically. It becomes an automobile. Then any further driving of the wheel on the part of humanity becomes superfluous. Progress begins to go into a skid like that caused when there is black ice. And the danger arises that, in the face of such progress without friction, humanity is run over precisely when it attempts to apply the brake. A situation which in a roundabout way reminds one of the eyes of Oedipus rebelling against the fateful wheel and his having to tear them out of his own head. This perhaps explains the attempt nowadays to turn off the wheels and jump across from the world of vehicle wheels into another world that is still to be experienced. This essay has been an attempt to look backwards one more time before jumping out of the automobile rolling along without friction, so as to catch sight one more time of the radiant secret behind the skidding wheels, that radiant secret by which this whole story was originally set in motion.

Biographical Note

1920 Vilém Flusser is born in Prague on 12 May. He grows up in a family of Jewish intellectuals; his father, Gustav Flusser, is a Professor of Mathematics at Charles University.

1931 Attends the Smichovo Gymnasium in Prague.

1939 Begins studying philosophy at Charles University in Prague.

1940 Escapes to London with Edith Barth.

End of 1940 Both emigrate to Brazil.

1941 Marries Edith Barth in Rio de Janeiro.

1950–61 Works in industry. Directs a transformer factory in São Paulo. At the same time, continues studies in philosophy – 'i.e. one did business in the daytime and philosophy at night'.

1957 First publications on questions of linguistic philosophy in *Suplemento Literário do Estado de São Paulo*.

1959 Appointed Lecturer in the Philosophy of Science at University of São Paulo.

from 1960 Permanent member of staff of *Suplemento Literário do Estado de São Paulo*. Publishes first contributions to *Revista Brasileira de Filosofia*, journal of Brazilian Philosophical Institute, São Paulo.

from 1961 Regular publications in a number of Brazilian journals, such as *Cultura Brasileira*. *Folha de São Paulo*, one of the country's biggest daily newspapers, sets up a column, 'Posta Zero'.

1962 Member of Brazilian Philosophical Institute, São Paulo.

1963 Appointed to Chair of the Philosophy of Communication at University of Communication and the Human Sciences (FAAP) in São Paulo. Member of Committee of *Fundação Bienal das Artes*. First book is published: *Lingua e Realidade* (São Paulo: Herder).

1964 Assistant editor of *Revista Brasileira de Filosofia*.

1965 Lectures on linguistic philosophy at Faculty of Humanities of Technological Institute of Aeronautics, São Paulo. Publishes *A História do Diabo* (São Paulo: Martins).

from 1966 Regular contributor to *Frankfurter Allgemeine Zeitung*.

1966 Publishes *Filosofia da Lingages* (Campos de Jordão: ITA) and *Da Religiosidade* (São Paulo: Commissão Estadual de Cultura).

1966–67 Emissary of Brazilian Foreign Ministry for cultural co-operation with North America and Europe.

from 1967 Guest-lectures at North American and European universities. Participates in international congresses. Publishes in European and North American journals, including *Artitudes* (Paris), *Communication et langages* (Paris), *Main Currents* (New York) and *Merkur* (Munich).

1972 Due to conflict with the military government, the Flussers move to Europe, settling in Merano. Flusser works on a philosophical autobiography, *Zeugenschaft aus der Bodenlosigkeit* (Testimony of Rootlessness), part of which is published in 1992 by Bollmann (Düsseldorf and Bensheim) under the title *Bodenlos* (Rootless). Publishes *La Force du quotidien* (Paris: Mame).

1973 Moves to Robion in the south of France. Works on a phenomenology of human gestures.

1974 Publishes *Le Monde codifié* (Paris: Institut de l'Environnement).

1977 Publishes *L'Art sociologique et la vidéo à travers la démarche de Fred Forest* (Paris: Collection 10/18).

1979 Publishes *Natural:mente* (São Paulo: Duas Cidades).

1981 Publishes *Pos-história* (São Paulo: Duas Cidades). First book-length publication in German, *Für eine Philosophie der Fotografie* (Göttingen: European Photography) (since translated into eight languages).

1985 Publishes *Ins Universum der technischen Bilder* (Göttingen: European Photography) and *Vampyroteuthis infernalis* (together with Louis Bec) (Göttingen: Immatrix Publications/European Photography). *Die Schrift: Hat Schreiben Zukunft?* is published simultaneously in book form and on disk by Immatrix Publications/European Photography.

from 1985 Lectures frequently in Western Europe, particularly in Federal Republic of Germany. Publishes articles, essays and commentaries in magazines and newspapers, including *Artforum* (New York), *Leonardo* (Berkeley), *Spuren* (Hamburg), *kultuRRevolution* (Essen), *Design Report* (Frankfurt am Main), *Kunstforum International* (Ruppichteroth), *Arch+* (Aachen).

1986 Publishes *Krise der Linearität* (Berne: Benteli).

1989 Publishes *Angenommen: Eine Szenenfolge* (Göttingen: Immatrix Publications/European Photography).

1990 Publishes *Nachgeschichten* (Düsseldorf and Bensheim: Bollmann).

1991 Publishes *Gesten: Versuch einer Phänomenologie* (Düsseldorf and Bensheim: Bollmann).

Vilém Flusser dies on 27 November in a road accident near Prague, shortly after visiting the city of his birth for the first time in more than 50 years.